Creative

COLLAGE
TECHNIQUES

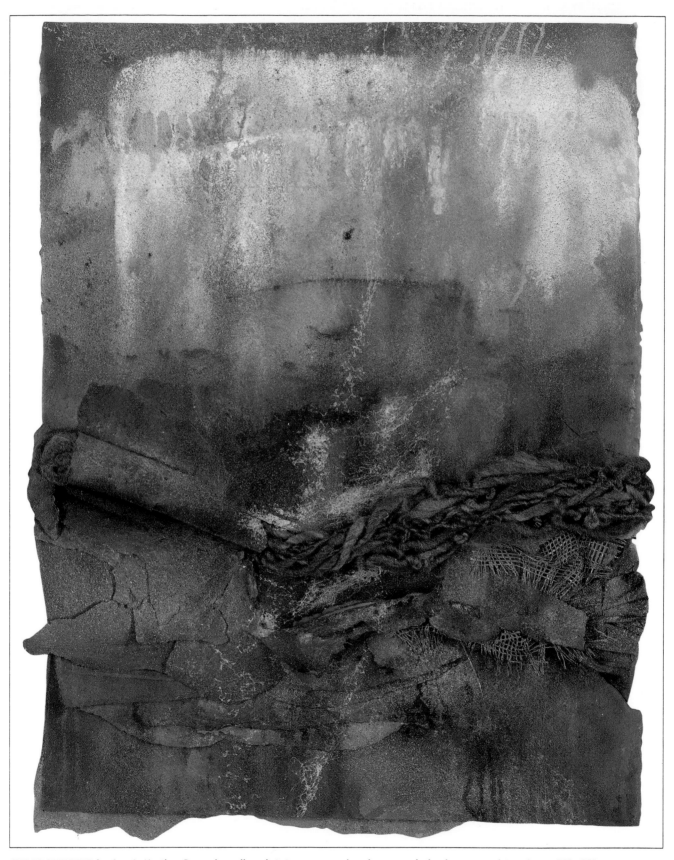

CHACO REVISITED by Ann L. Hartley. Poured acrylic paint, torn papers, hand-spun and -dyed yarns, and torn bags, 30″ × 23″.

Creative
COLLAGE
TECHNIQUES

NITA LELAND AND VIRGINIA LEE WILLIAMS

NORTH LIGHT BOOKS

CINCINNATI, OHIO

ACKNOWLEDGMENTS

Everyone who has touched our lives has contributed something to this book—family, friends, teachers and students—and for that we are deeply grateful. Virginia Lee feels especially indebted to Roy Ray of Cornwall, England, whose instruction in layering started her in exciting, new directions and to Martha Patterson for opening Virginia's eyes to color. Special recognition is due more than seventy artists whose fine work appears here, with extra thanks to Pat Clark, Thelma Frame, Joan Marcus and Elaine Szelestey. Thanks to George Bussinger, Jr. and Lesley Walton of Ken McCallister, Inc., to Ron Cercone and Roderick Phillips of Cer El Color Lab, to Bruce Wall of Binney & Smith, makers of Liquitex Acrylics, to Barbara and Mark Golden of Golden Acrylics, and to Dr. Ph. Martin Co. for assistance with technical questions. Also, we're indebted to our editors at North Light, Greg Albert, Rachel Wolf, Bob Beckstead and Diana Martin for their moral support and advice. A word of appreciation to our helpers in the Olde Town neighborhood: Gene Spatz, Robin Strawser and Sheila Elmore, and especially to Ken, our patient "gofer," for putting up with us all the way through.

METRIC CONVERSION CHART

To Convert	To	Multiply by
Inches	Centimeters	2.54
Centimeters	Inches	0.4

98 97 96 95 94 5 4 3 2 1

Library of Congress Cataloging in Publication Data
Leland, Nita.
 Creative collage techniques / by Nita Leland and Virginia Lee Williams.
 p. cm.
 Includes index.
 ISBN 0-89134-563-9
 1. Collage—Technique. I. Williams, Virginia Lee. II.Title.
N7433.7.L46 1994
702'.8'12—dc20 93-46273
 CIP

Edited by Diana Martin
Interior and cover design by Clare Finney

Virginia Lee dedicates this book to her mother, Hilda R. Dickenson,
and to her husband, Kenneth, for their faithful love and support.

Nita dedicates the book to the Fab Four and, one more time, to R.G.L.

Both of us dedicate this book
to friendship.

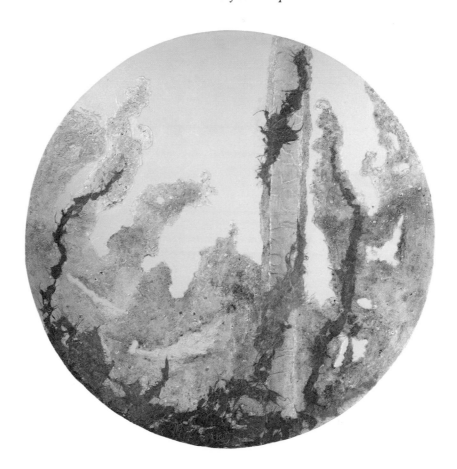

Table of Contents

PART FOUR: MIXED MEDIA COLLAGE

Combine paper collage with a variety of other mediums to expand your capabilities of creative expression.

PART FIVE: MAKING COLLAGE SUPPORTS

Create fantastic textured backgrounds with mediums, paper and natural materials to make your collages original and exciting.

PART SIX: MAKING COLLAGE PAPERS

Make elegant and distinctive papers with paints, pulp and mediums, and use them to create unique collages.

PART SEVEN: THE FINISHING TOUCHES

Explore this concluding section to discover everything else you've always wanted to know about collage!

Preface

The world of collage is like an amusement park with something for everyone, from the dignified round of a carousel to wild ups and downs on a roller coaster.

No other creative medium is so accessible to people of all ages and skill levels. Collage, which is friendly and non-intimidating to the beginner and challenging and complex to the accomplished artist, offers exciting visual effects and enormous expressive potential. Collage lends itself to spontaneity and creativity. Unlike painting and drawing mediums, where a stroke of the brush or pencil is a commitment, collage is a constant metamorphosis. It's a treasure hunt for just the right piece to fit the collage puzzle. The pieces can be shifted, added to, removed, glued down, covered over or torn off. Some artists say that a collage is never really finished. It's fun to go back into an old collage and bring it up to date.

Are you curious about how collages are made? This book opens with a brief history of how collage began. Then you'll make your own collages with simple materials and techniques like those used in early collages. You don't need drawing or technical skills to begin. Jump in wherever you feel most comfortable. You'll soon be ready for more advanced projects. You'll use "found" and ready-made papers first, then you'll learn how to make your own exciting, richly colored papers and textured supports for collage.

When you're ready to break with tradition, collage is a great way to challenge yourself and to stimulate your creativity. You can even recycle trash into collage art objects, make a social or environmental statement, or explore your spiritual nature through the philosophy of layering. We'll show you how to make art that will last, using sound methods to prepare your materials.

Here's your chance to try collage: doable projects with helpful instructions, dozens of examples to help you, demonstrations showing you how to use collage in your work, and lots of ideas to stimulate creativity and originality. You'll feel as though you've caught the brass ring on the carousel!

Some art critics say that collage is the single most revolutionary artistic innovation in our century. In some ways collage is revolutionary and reactionary at the same time. Collage techniques range from simple craft creations based on centuries-old customs to innovative constructions made possible only by modern technology. Collage as an art form is uniquely a twentieth-century phenomenon with the capacity to dominate visual art in the twenty-first century. Now, start on your way, back to the future of art. Onward—to the twenty-first century creative art of collage!

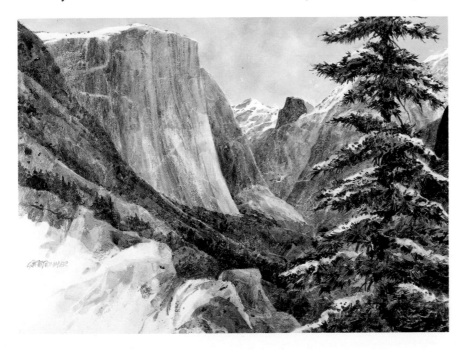

EARLY SPRING, YOSEMITE by Gerald F. Brommer. Watercolor and rice paper collage, 22″ × 30″. Courtesy of Fireside Gallery, Carmel, California.

Some of the most beautiful artworks made today are convincing, realistic images that combine watercolor with basic paper collage techniques.

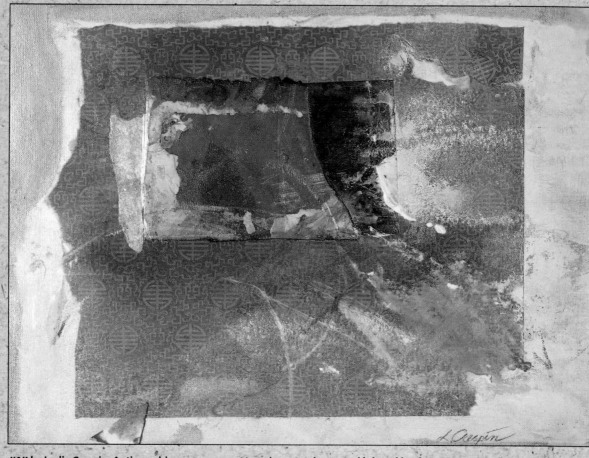

"A" by Leslie Crespin. Antique chinese papers, watercolor, pastel, pen and ink and leather, 12" × 14". Collection of Gay and Roger Falkenberry.

People have been making collages since the invention of paper, but collage has come into its own as an art form in the twentieth century.

ABOUT COLLAG

1

Introduction

WHAT IS COLLAGE?

The *American Heritage Dictionary* defines collage as "an artistic composition of materials and objects pasted over a surface, often with unifying lines and color." The origin of the word is French: *coller*, to glue. Anything that is glued or pasted onto something else might be broadly interpreted as collage. The techniques we know as collage today were no doubt known by other names in the distant past. Pablo Picasso and Georges Braque launched collage into the mainstream of art in Paris in the twentieth century and popularized the term. Much early experimentation in collage took place in France, thus the collage vocabulary has a distinctly French accent.

Collage probably existed before the invention of paper, certainly long before the technique was thought of as artistic. Many people still view collage as a craft rather than an art, but you'll soon see that the fine art of collage can be as formal, as challenging, and as expressive as painting.

In this book the emphasis is on *papiers collés* — pasted papers — with other materials added occasionally by whim or by design. Most collage is based on ordinary materials, such as magazines, newspapers, photos, wallpaper or fabric, used creatively. As art critic Donald B. Kuspit said, "Collage makes poetry with the prosaic fragments of dailiness."

You've probably made many collages already. Did you make valentines in school? Cut and paste black and orange construction paper for Halloween jack-o-lanterns? Put together a scrapbook or photo album? These are all collages. It's a very short step from these common activities to the fine art of collage.

THE CREATIVE BREAK WITH TRADITION

Collage has almost universal appeal to artists who constantly search for other means to add more excitement to their work and for different ways of being creative. Collage, more than any art

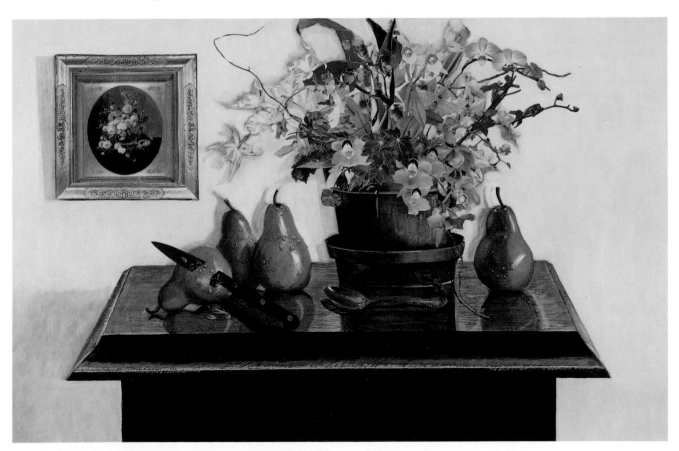

ORCHID AND PEARS by Maya Farber. Acrylics and collage, 24" × 36".

This beautiful composition is a fine example of a traditional cut-and-pasted paper collage. The solid shapes and clean edges of this still life work well in the collage medium.

medium, offers myriad opportunities for invention and innovation.

In *Collage: Critical Views*, Katherine Hoffman wrote,

The [collage] fragments are experienced as profoundly meaningful, but the meaning cannot be spelled out completely and never seems to truly surface—which is what leaves the artist free to arrange the fragments as he wishes, in a whimsical or a willful way. This gives the collage an aura of creative freedom which is crucial to its sense of liveliness and to the artist's sense of self-determination.

The versatility and flexibility of collage offer infinite possibilities for the arrangement of elements, unusual juxtapositions and transformation of images and meanings. The possibility of change always exists. You can add something and remove or cover up something else. Almost anything that can be readily manipulated can contribute to the visual and tactile sensuality of the collage surface. No other medium will give you such a variety of exciting alternatives.

THE FUN BEGINS

Collage can be as simple or as complicated as you like. Anyone can do it. Take this fascinating medium as far as you want to go with it. Reach for the stars from the top of the Ferris wheel! It won't cost much if you start with simple, discarded materials. Don't think about making art. If you're an artist, pretend you're a beginner and play for awhile. Start with the projects on pages 4 to 6 and have fun!

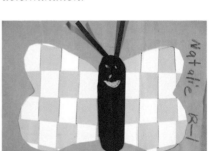

BUTTERFLY by Natalie M. Laight. Woven paper and collage, 8½" × 11".

Do you remember doing collages in school? Children love collage because of the capability of playing with the materials without having to make a commitment to a brushstroke.

Collage Terms

AFFICHES LACERÉS (a-fish́ lah-ser-ay´) Found paper collage

ASSEMBLAGE (ah-se m-blah´j) Combination of three-dimensional objects glued to a surface

BRICOLAGE (bree-col-ah´j) Combining odds and ends in collage

BRÛLAGE (brew-lah´j) Burning of dampened collage materials

COLLAGE (ko-lah´j) Pasting or gluing papers or objects onto a surface

DÉCALCOMANIE (daý-kal-kó-mahn-ee) Placing wet paint between two surfaces and pulling apart

DÉCHIRAGE (day-shur-ah´j) Distressed paper collage

DÉCOLLAGE (day-ko-lah´j) Removing, ungluing or otherwise subtracting material from the layers of a collage

DÉCOUPAGE (day-koop-ah´j) Cut paper collage

FEMMAGE (fahm-ah´j) Collage art and traditional craft done by women, frequently fabric-oriented

FROISSAGE (fwahs-ajh´) Crumpling or creasing of collage materials

FROTTAGE (frot-ah´j) Rubbing a design onto collage materials from a textured surface

FUMAGE (foom-ah´j) Exposing dampened collage materials or surface to candle smoke

LAYERING (laý-r-ing) Building and removing layers of collage materials; a philosophy of connecting spiritual energies with art

MIXED MEDIA COLLAGE Any combination of media with collage

PAPIERS COLLÉS (pah-pee-aý ko-laý) Pasted papers

PHOTOMONTAGE (fo-to-mahn-tah´j) Collage of glued photographs or cut-out photos

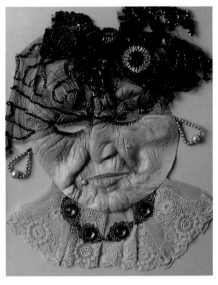

ART EXPO by Paul G. Melia. Acrylics and pencil with paper collage on illustration board, 30" × 20".

Striking graphic design is the strong point of this collage, with traditional materials used inventively. The picture could be painted as flat art, but the use of materials of diverse textures and weights is much more effective.

THE DOWAGER by Beverly Goldsman. Fabric, sequins, jewelry and plastic mask, 13½" × 10½".

An outrageous sense of humor frequently sparks the artist to turn unexpected materials into collage. For this approach to collage, a trip to the flea market is better than shopping in an art materials store.

Most people don't realize when they're pasting their memories in a scrapbook or photo album that they're making collages on every page. The only problem is that the adhesives and papers they use don't hold up, and the albums eventually fall apart.

PROJECT ONE: A Treasure Hunt for Collage Materials

You can use almost anything in collage. Since no special skill with a medium is required, collage is one of the easiest ways to get involved in the creative process. Techniques and materials range from pasting ordinary items, such as newspapers and greeting cards that are found in every home, to inventive arrangements of unusual materials like personal diaries or religious artifacts that invite emotional and intellectual interpretation. Anything goes, from personal observation to social commentary.

What makes a collage material? Anything that will stick when you glue it to a flat surface. The more objects you have, no matter how ridiculous they might seem, the sooner you will find something to start the creative process bubbling. Throw your collage materials, whatever you can get your hands on, into your treasure chest—a cardboard box.

For this first collage project, create what you imagine would make a good collage from "stuff" you find around the house. Use your imagination. Don't buy anything new. You artists, stay out of your well-equipped studios for this project! Do you have a junk drawer in the kitchen? Scraps of fabric, yarn, ribbon, buttons in the sewing room? Nuts and bolts in the garage? Glue whatever you find to any kind of surface with any type of glue or adhesive. Don't worry if the whole thing self-destructs tomorrow. The fun is in doing it today. Tomorrow you can learn to do it right. *Go!*

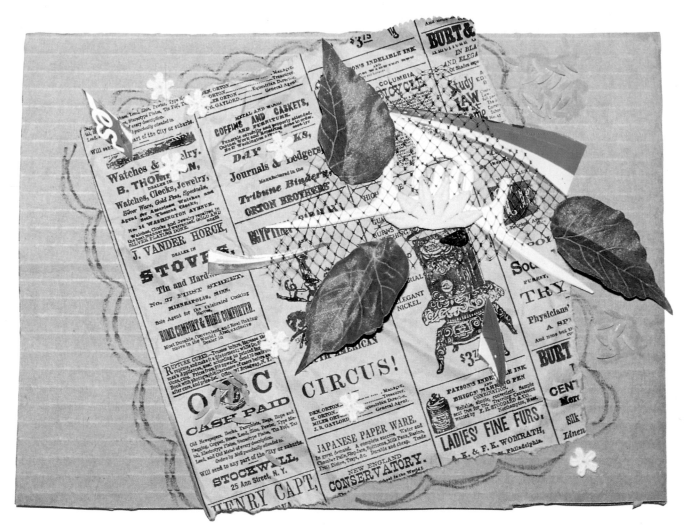

Cut up things like soapboxes, gift wrap, mesh bags and plastic leaves to make your first collage on a piece of ordinary cardboard.

(Right)
Gather together odds and ends around the house to glue on a collage. It isn't hard to find colorful scraps you can use, and you probably have a container of white glue or paste.

(Below)
ANYTHING GOES by Virgie J. Click. Found objects, braided hair and acrylics on canvas, 20″ × 24″.

A hairstylist made her first collage with antique items used in beauty salons, arranged in a simple abstract shape. Sometimes this approach is called assemblage, rather than collage.

PROJECT TWO: Making Rubbings for Collage

Another quick-start project for collage is *frottage* — rubbing a design or pattern onto a piece of paper, then using the simulated texture in a collage. First, gather up a collection of objects with textured surfaces, such as embossed wallpaper, coins, wood, mesh bags, berry boxes, leaves, feathers and stencils. Place a fairly thin sheet of white paper, such as typing paper, over the object and rub the paper with a soft pencil to transfer the pattern. Be careful not to tear the paper. Rub lightly for subtle texture, heavily for dark, bold patterns. Make an assortment of these textured papers and include colored papers and rubbings with colored pencils, charcoal or pastel. Smudge to blend colors; erase to lighten them. Cut and tear the pieces into interesting shapes, arrange a design, and glue them to cardboard or heavy paper.

Collect an assortment of objects that have textures on them. Place paper on top of these patterned objects and transfer the patterns by rubbing the paper with a soft graphite or colored pencil.

Cut out the patterned rubbings and arrange them on a background of cardboard or heavy paper. Glue with household white glue.

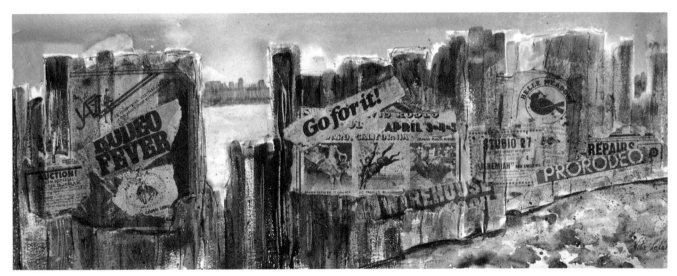

GO FOR IT by Nita Leland. Newspaper collage and watercolor on watercolor board, 15" × 30". Collection of Dr. and Mrs. Dale Marcotte. Collage is great fun. Give it a whirl.

CHAPTER ONE

The Origins of Collage

Collage has a long and distinguished history. No matter what you may do in collage, chances are it has been done before, but certainly not like you will do it. You can study early collages of the Japanese or Dutch, for example, and then revive an old idea with a new twist, giving a contemporary look and feel to an ancient technique.

The story begins with the invention of paper in China around 200 B.C., but the earliest examples of paper collage are the work of twelfth-century Japanese calligraphers, who prepared surfaces for their poems by gluing bits of paper and fabric to create a background for brushstrokes. Later, in the fifteenth and sixteenth centuries in

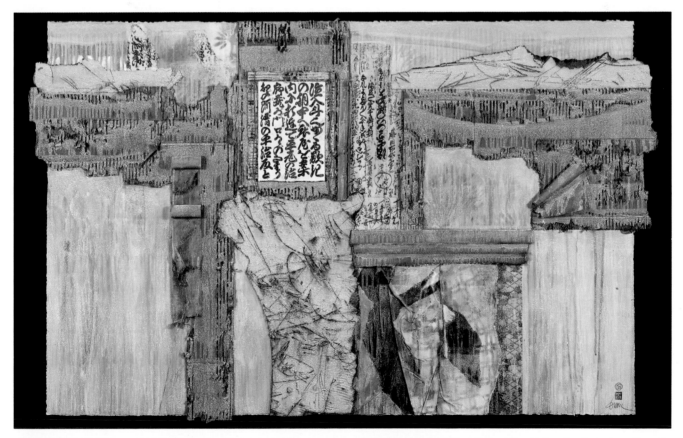

KYOTO RIDGE SERIES—KINKI NIPPON by Stanley Grosse. Mixed media and oil base paints with collage, 40″ × 60″. Collection of Kentwoods Estate.

This combination of calligraphy and collage calls to mind one of the earliest uses of collage by the Japanese, as a background for lettering.

the Near East, craftsmen cut and pasted intricate designs and used marbled papers as part of the art of bookbinding. Today's collage artists invent exciting variations of these ancient collage techniques.

Artists in medieval times, beginning in the thirteenth century, often enhanced religious images with gemstones, elegant fibers, relics and precious metals. Later, in the seventeenth and eighteenth centuries, nuns made bookmarks trimmed with cut and colored papers, which they carried in their prayer books. Frequently, the materials used were selected for their symbolism, a practice that continues in contemporary collage.

Renaissance artisans of the fifteenth and sixteenth centuries in western European countries pasted paper and fabric to decorate the backgrounds of coats of arms in genealogical records. Cut-paper silhouettes appeared in the Netherlands in the seventeenth century. Craftsmen in prehistoric and primitive societies in many parts of the world used seeds, shells, straw, feathers and butterfly wings as collage material. Shamans and holy men in some societies secured these and other materials to masks used in sacred rituals. All of these materials appear occasionally in artists' collages today.

ANTIQUES AND UNIQUES

During the nineteenth century collage developed as a popular art, more of a hobby than an art form. People pasted family photographs into arrangements and hung them on the walls, glued postage stamps into albums, and covered screens and lampshades with magazine illustrations and art reproductions. In antique shops today you can find nineteenth-century scrapbooks, photo albums, silhouettes

and lampshades made of assorted materials: paper, fabrics, human or animal hair, and a variety of memorabilia. Most of these materials were mementos and family heirlooms, not art objects. Yesterday's elaborate valentines provide inspiration for children's craft projects today.

There were a few serious collage artists in the late nineteenth century, pasting intricate paper cutouts onto backgrounds. Hans

Christian Andersen created illustrations for a book this way. Carl Spitzweg made collages for a collection of recipes with cutouts from woodcuts, which he colored by hand and pasted onto marbled papers. In the last decade of the nineteenth century, graphic artists arranged type and bold, cut-out shapes to create theater posters and illustrations. The introduction of photography led to photomontage, the combining of photo-

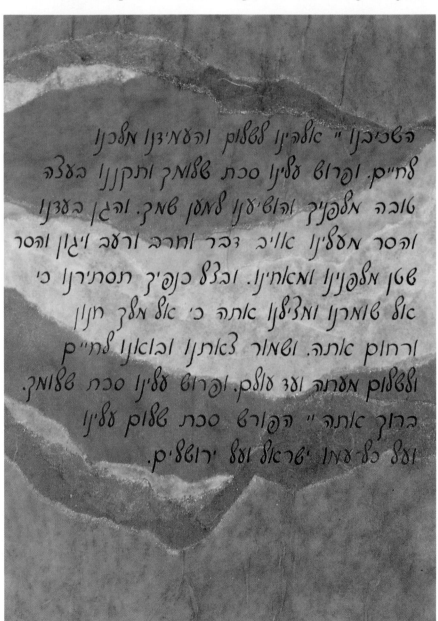

HASHKIVEYNU – HEBREW PRAYER FOR PEACE by Joan A. Marcus. Inks and gold paint on rice paper, 13¼ × 9¾".

In her interpretation of ancient collage, Marcus applied Hebrew calligraphy to rice papers.

graphs into artistic arrangements. In time, the photos and posters themselves became collage material.

COLLAGE AS A MODERN ART

The twentieth century shed an entirely new light on collage. Katherine Hoffman stated that "Collage may be seen as a quintessential twentieth-century art form with multiple layers and signposts pointing to the possibility or suggestion of countless new realities." Art historians generally attribute the first use of collage in fine art to Pablo Picasso in 1912, when he glued a piece of patterned oilcloth to a cubist still life. Next, Georges Braque incorporated wallpaper into his artwork. The two artists experimented with *papiers collés* as an extension of cubist principles. Instead of creating an illusion of reality, they invented a new kind of reality, using textured and printed papers and simulated wood patterns on their drawings and paintings. Imagine the storm of controversy that followed these experiments. The use of foreign materials in paintings inflamed critics,

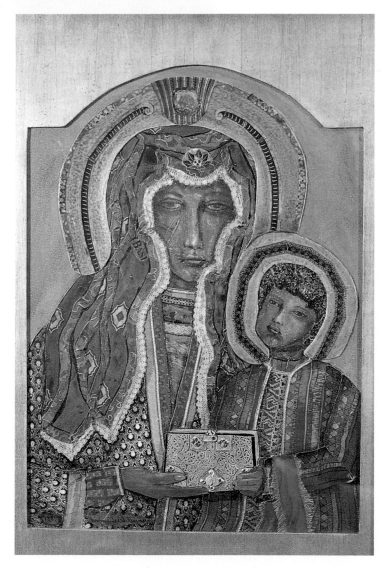

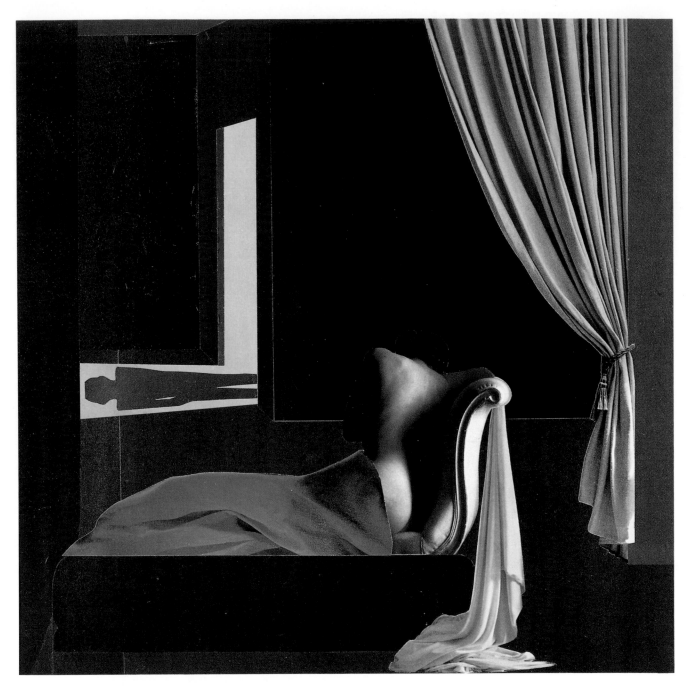

THE DRAWN DRAPE by Deborah Krejsa. Paper collage, 13″ × 12½″.

An unusual juxtaposition of cut-out pictorial elements results in a strangely surrealistic effect of light and shadow in this collage made from magazine pictures. Collage pieces are selected so they suggest a common light source.

adding more fuel to the creative fires of experimental artists.

The avant-garde adopted this new approach and quickly branched out. Cubists used mostly paper and paint, sometimes in a patchwork quilt fashion, with the occasional realistic object added to support a pictorial concept or philosophical viewpoint. Futurists incorporated typography for political commentary and added found objects to connect art with the real world. Dadaists found collage an ideal means of expressing anti-art nonsense, bringing together outrageous combinations of materials for shock value. The new science of the mind, called psychology, led surrealists to see collage as a revelation of unconscious thoughts brought to the surface through the random selection and placement of materials.

PROJECT THREE: A Matisse Collage of Your Own

Artists like Matisse and Albers cut and pasted colored papers. You, too, can create a collage using this technique. Collect a few materials from around the house: scissors, white glue, white cardboard, and assorted colored papers or magazine pictures with bright, colored illustrations and advertisements. Cut out large, interesting, colorful shapes and glue the pieces to the cardboard. Repeat some of the shapes and colors throughout the design. Make it a bright, playful collage, *á la Matisse*.

Cut out simple, decorative shapes from any type of colored paper. No need to draw. Just cut them out freehand, like cutting out paper dolls.

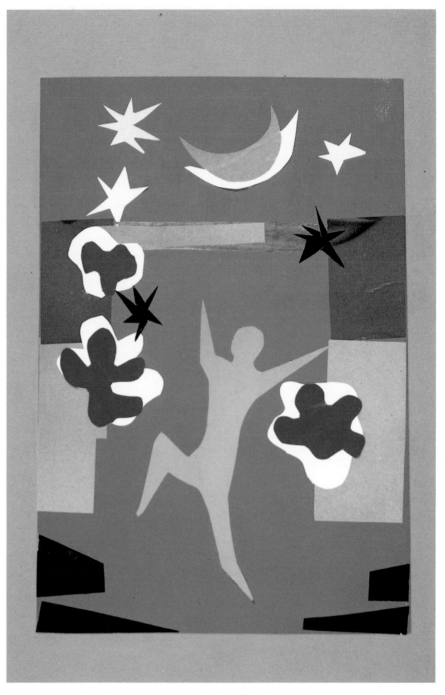

JUMP FOR JOY by Nita Leland and Virginia Lee Williams, 11" × 8".
Glue your cut-outs onto a colored paper or board. Voilá! Your own Matisse collage.

OTHER DEVELOPMENTS IN COLLAGE

Kurt Schwitters was among the first to see collage as a medium in its own right, rather than as an extension of painting. He picked up trash and used it in collage. Max Ernst defined the "collage idea," the principle of accepting as valid whatever occurs on the support during the process. André Breton and other European artists carried collage to the frontier of American abstract expressionism, where it was advanced by Robert Motherwell, Lee Krasner, Louise Nevelson, Robert Rauschenberg, Jasper Johns and others.

"Thus collage principles, and extensions and variations of collage, have opened the door to an endless stream of artistic and critical innovations and expressions," according to Katherine Hoffman.

Early twentieth-century collage represented a radical break with artistic tradition through the addition of a few scraps of paper to a painting. By the end of the century, artists had become aware of the tremendous potential of the medium for creative artistic expression. Robert Courtwright, Miriam Schapiro, Romare Bearden and other artists exemplify the best of what can be accomplished in the collage medium, both experimentally and realistically.

COLLAGE FOR THE TWENTY-FIRST CENTURY

[Collage], which takes bits and pieces out of context to patch them into new contexts, keeps changing, adapting to various styles and concerns. Kim Levin

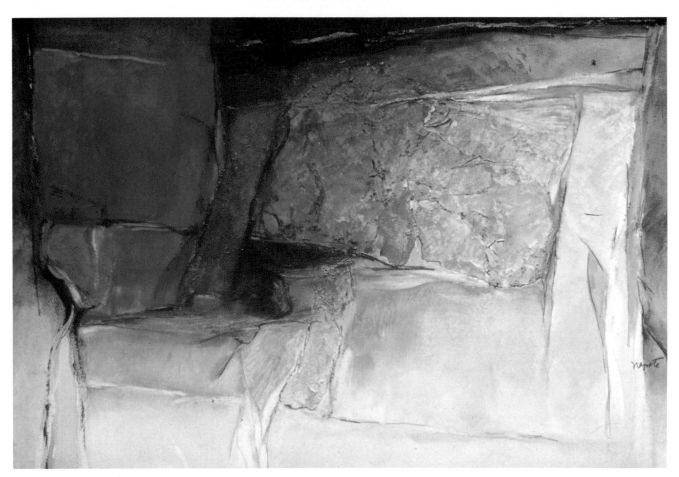

ROCK MOSAIC by Alexander Nepote. Water media and torn papers, 30″ × 40″. Courtesy of Hanne-Lore Nepote and "The Gallery," Burlingame, California.

Much of the new art of collage is based on the work of abstract artists like Nepote, who integrated paper collage and water media artworks, suggesting natural phenomena in a painterly manner.

Sometimes collage reflects the disposable mindset, the urban environment, conservation and ecology. Certainly collage is a novel way to recycle bits and pieces that might otherwise find their way to the trash bin. Along with new techniques and materials, including acrylic polymer mediums introduced in the 1960s, ideas have proliferated about whether or not there is a symbolic or psychological aspect to the way a person selects, combines and arranges collage materials. Even the most realistic collage seems to suggest a deeper meaning beneath the visual image. The layerist group, which includes many collage artists, explores this interpretation of the new art, along with mysterious imagery and spiritual connections.

Most people are fascinated by the transformation of common, ordinary materials and the intermingling of disparate elements, many of which they are familiar with in other contexts. Viewers examine the layers and objects for recognizable fragments, then attach their own meaning to them. They become participants, instead of merely observers.

Collage better than any other technique permits us to single out the successive stages of the artist's work. The eye is no longer content with an overview of the surface. Florian Rodari

In spite of its short history as an art form, collage seems destined to become the art of the future. And you can become a part of this.

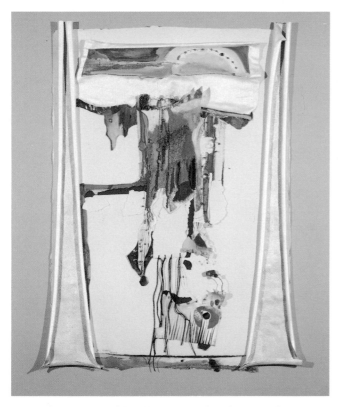

WEST II by Jeny Reynolds. Oil on canvas, handmade Indian paper, beads, wire, leather and string, 40" × 30".

Mixed media collage is frequently three-dimensional, even when arranged on a flat surface. Papers and fabrics are draped and objects placed to create shadow patterns on the background.

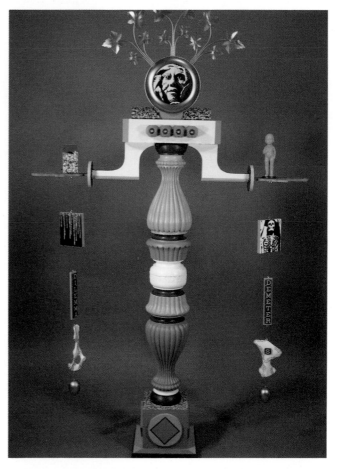

DEMETER'S DILEMMA by Richard Newman. Mixed media sculpture with polychromed wood, metal, fabrics, photos, bones and found objects, 68" × 42" × 10".

Newman's unusual sculpture suggests totem pieces of many civilizations around the world, which often have hidden meanings and ritual purposes. Common objects take on a new dimension in this unlikely combination.

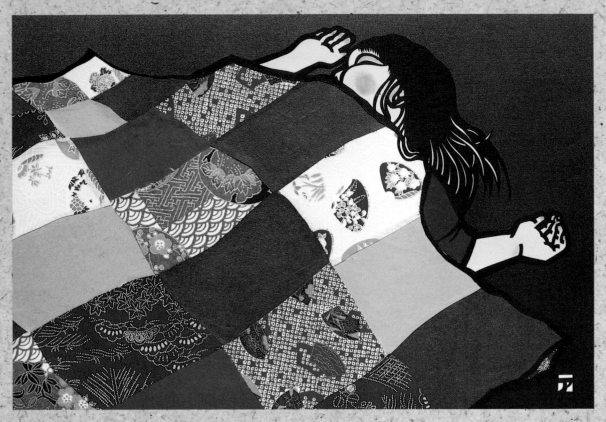

NAP by Aki Sogabe. Cut rice papers, acid-free paste, 16″ × 20″. Private collection.

Make collages with magazines, newspapers and colored papers, starting with materials at hand and progressing to traditional art materials.

CHAPTER TWO
Getting Started

Getting started in paper collage is easy, since materials are readily available and affordable. Start by collecting odds and ends, such as photos, mementos, magazine pictures and wrapping paper. As Florian Rodari aptly said, "Anything that addresses itself to the eye will do." Store your collection of collage materials in plastic bags or a cardboard box.

If you are a beginner, let yourself enjoy making collage pictures without worrying about artistic concerns. It's easy and fun. If you are a more experienced artist, approach this exciting medium as though you, too, are a beginner, so you have a solid foundation for the more complex processes introduced later in this book. Collage can be a serious art or a playful change of pace from your usual medium.

Start with paper and white glue or acrylic medium, if you have it.

If you want to paint your collage, use water-soluble media—transparent watercolor, gouache, casein or acrylics—but not oil-based paints, which require strong solvents for cleanup and may cause papers to deteriorate. Also, note that acrylic mediums used to adhere papers and to coat supports and finished collages will not bond to oil-based materials.

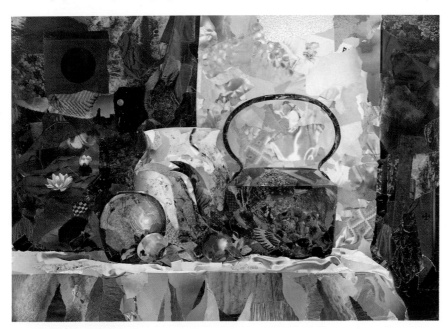

THE IRON KETTLE by Bob Kilvert. Paper collage, 32″ × 45″. Courtesy of The Old Corner House Gallery, Weobley, Herefordshire, England.

This magnificent realistic collage is an arrangement of torn pieces of magazine papers, some of the most readily available of all collage materials. Kilvert's palette for this still-life theme collage is richly colored and textured.

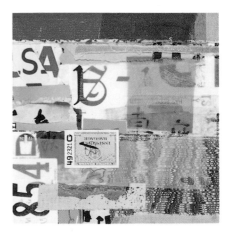

UNTITLED—(INSPECTED) by George Schroeder. Found papers, cloth, canvas and acrylics, 8¾″ × 8½″.

Found papers with intriguing lettering make interesting collage materials, here combined with mixed media. The artist emphasizes contrasting type styles.

PROJECT FOUR: Creating a Magazine Theme Collage

The easiest way to begin a collage is to select a theme, that is, a main idea that will unify your composition. A theme can be anything that reflects your special interests: fashion, show biz, sports, family, art, pets, nature, ecology and so on. You probably have an assortment of magazines and brochures around the house; look through several of them for theme ideas.

Next, select a subject based on your theme. For example, if your theme is sports, pick a particular sport, such as tennis, golf or baseball, as the subject of your collage. Collect lots of pictures and words that relate to your theme. You don't have to use them all, but you need a big selection to choose from. Save what you don't use for other projects.

The materials you need are simple, affordable and easily accessible: a piece of cardboard (such as the back of a tablet or drawing pad), scissors, white glue, crayons or markers, a large container of water (at least a half gallon), a damp cloth or sturdy paper towels, and an assortment of magazine pictures.

Cover a table with newspapers. If necessary, cut the cardboard support to a workable size, between 11″×14″ and 16″×20″. Cut (to make hard edges) or tear (to make soft edges) magazine pictures and words representing your subject. Create a variety of paper sizes, shapes and colors. Arrange the pieces on the cardboard support without gluing them down. Keep it simple and don't worry about art rules. Please yourself.

When you have an arrangement you like, glue the pieces to the cardboard, starting with the big

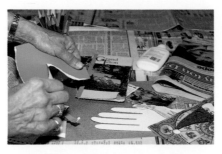

Some papers show white on one edge when torn. This can be useful as an accent in collage to create a contrasting or linear effect. Practice tearing with and without white edges. Papers all react differently in this respect.

Cover the back of a collage paper completely with glue for the best adhesion. Place it carefully on the collage and pat it gently to adhere.

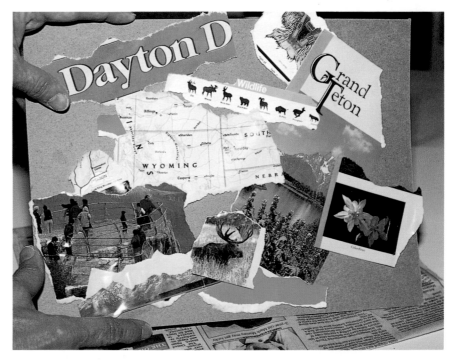

ROAMIN' IN WYOMIN' by Nita Leland and Virginia Lee Williams, 9½″×12½″.

This simple travel collage was made from a small map and a travel folder, and a few fragments of newspaper and colored paper, cut and torn, then glued to a cardboard tablet backing. Try different arrangements of the pieces before you glue them down.

pieces first. Using your fingers or an old, small paintbrush, spread white glue over the entire back of each picture. Press each piece firmly onto the cardboard, smoothing the pieces from the center out. Carefully wipe off excess glue with a slightly damp cloth or paper towel. Be sure the surface is free of glue, as the dried glue may cause shiny spots.

Use a pin to prick any large bubbles in the paper and release air. Then pat gently. Most of the wrinkles will disappear as the paper dries. When the collage is thoroughly dry, fill in background spaces with colored marker, crayon or watercolor. Then, turn the collage face down, lightly dampen the back, and weight it overnight with books or heavy objects to flatten it.

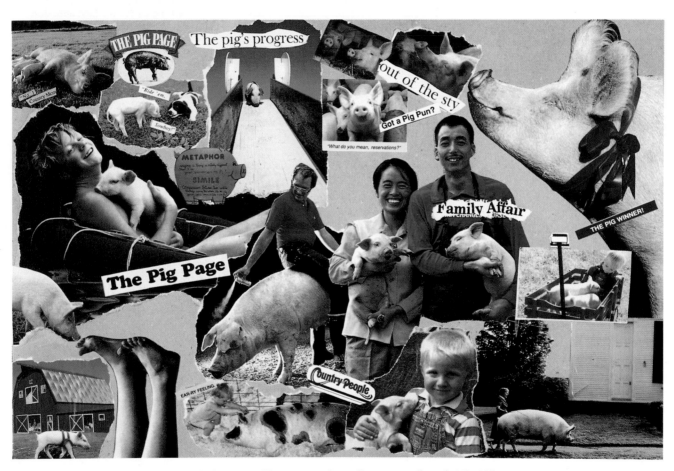

THIS LITTLE PIGGY by Nita Leland and Virginia Lee Williams. Magazine collage on cardboard, 12" × 18".

For a larger collage, search several magazines for images based on a single theme. The theme unifies the collage. Have some fun with it; select amusing images or arrange them in an unexpected way.

PROJECT FIVE: Creating a Found Papers Collage

The first step for this project is to search for a variety of papers. There are lots of papers around the house that make clever or beautiful materials. You can add some ideas of your own to this paper list. (See the Appendix for more ideas.)

art reproductions	foil papers
engravings	wallpaper
posters	letters
bills	envelopes
receipts	postcards
price tags	stamps
labels	maps
catalogs	travel folders
magazines	photographs
newspapers	playing cards
comic strips	shopping bags
greeting cards	ticket stubs
corrugated paper	programs
packing materials	tissue paper
diaries or journals	typing paper
dress patterns	wrapping paper
sheet music	

Sort your found papers according to color, subject matter or texture and place them in envelopes marked by category. File your paper collection, so you can find specific pieces easily when you need them. As your collection grows, expand your system to manilla folders filed in a plastic crate. When you become more serious about collage, you'll be glad you're organized.

Select materials from your assortment of found papers, looking for favorite colors, interesting textures or unique patterns. If your papers are transparent, thin or lacy, glue white wrapping tissue over the surface of your cardboard, so it won't show through. Let the tissue dry thoroughly before arranging your papers. As you have done with previous projects in this book, choose a theme: springtime, birthdays, Fourth of July or something nostalgic, imaginative or futuristic. Limit the number of papers you use; five or six would be about right to begin with. Then focus on a dominant element, such as one large piece, an interesting shape, or a beautiful texture. Place it on your cardboard support or on a flat surface next to the support. Arrange other pieces around that one, overlapping edges or tucking the corners under the edges of the large piece to enhance it. Add interest with bits of color or contrast.

Play with the pieces before gluing them down. Make creative adjustments. To aid in composing your collage, cut two L-shapes two inches wide out of white cardboard. By joining these shapes to form a rectangular mat, you can frame your collage periodically to study its composition. Step back for a better view.

Glue each piece carefully onto the cardboard, starting with the bottom layer. Remember to wipe off excess glue with a damp cloth. If the collage isn't flat when it dries, turn it over to the back side, dampen slightly, weight it down with heavy books or magazines, and let it dry overnight.

HOME SWEET HOME by Nita Leland and Virginia Lee Williams. Wallpaper, sheet music, dress pattern and wrapping paper collage, 18″ × 20¾″.

The papers in this collage can be found in most people's homes. The theme is less important here than the aesthetic arrangement of the collage materials.

PROJECT SIX: Working With Printed Words

You can create delightful collages without pictures by combining words and letters, printed in different typefaces, from magazines, newspapers and other sources (see the list on page 18). These unique arrangements are visually exciting and intriguing to the viewer who "reads" your picture. Gutenberg, who invented the first printing press in 1450, would be astonished at the variety of typefaces we have at our fingertips. Study the different shapes and spacing of type, the light and dark contrasts of the letters, and the personality of words as they are conceived by typeface designers. Collect interesting specimens of type and file them with your collage materials.

Before you start composing this word collage, you need to get a feeling for the visual effect of black-and-white design. First, cut or tear a large assortment of blocks of type from your paper sources, selecting different degrees of contrast so that collectively they represent a range of light-to-dark values. Use thin,

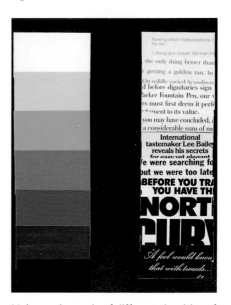

Make a value scale of different densities of type, so you can see a difference between the values, based on the spacing of the letters and weight of the type. This exercise will improve your sense of designing in black and white.

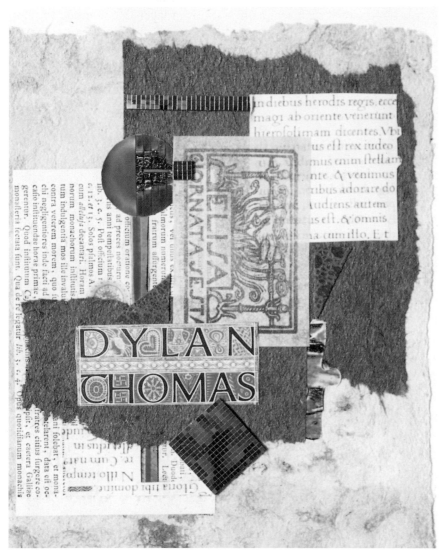

DYLAN THOMAS by Carolyn Dubiel. Bark, handmade paper, leather and type, 19" × 16". Collection of Joan and Harold Simpson.

Dubiel calls this "a study in textures and type," an effective way to explore a collage idea without an actual subject. Assorted papers and type styles are effectively set off against a harmonious color scheme that doesn't draw attention from the collage elements.

widely spaced letters for light values and densely spaced lettering for dark values. Arrange these on a scrap of heavy white or black paper or cardboard to show gradation from white through gray to black. To evaluate the relationships, squint your eyes tightly; this will eliminate distracting elements, focusing your eye only on values and contrast. When you have a consistent change from light to dark, glue the pieces.

Your typeface collages will be more effective if you employ contrasting values like those on your value chart. After you have worked out the value exercise, assemble a print collage on cardboard, using complete words you find in your source materials. Use printed material that is black or white only. Your collage might be humorous, or it might make a powerful political statement. Consider throwing in a little shock from time to time. Your theme could be a hobby, your family, your philosophy of life, something you love or something you hate.

Use words or letters in type styles that emphasize the light and dark contrasts of the pieces you're working with. For example, incorporate bold black letters against a stark white background, or add decorative bits of type for a light, Victorian look. Move the pieces around till you like the arrangement, then glue them down. You can enhance a typeface collage with touches of colored marker or crayon, if you like, but don't overpower the type.

SEEING BEYOND by Sharon Summers. Acrylics, colored pencil, leaves and found materials on plywood, 45" × 28".

This impressive arrangement is a more complex use of magazine and type collage in combination with mixed media. Paint ties areas together and modifies the edges of collage materials.

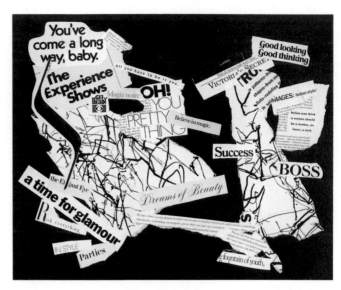

OH! by Nita Leland and Virginia Lee Williams. Print collage, 15" × 20".

This theme collage is created from words instead of pictures, assembled to make an interesting contrast against a black background. It's fun to read collage pictures made with type. Small pieces of type have been combined to create large design shapes.

Getting Serious About Collage

Collage art is simple when you use materials you find around the house, like magazines, scissors and glue. But by upgrading materials, you assure that your finished pieces will last for a long time. This chapter describes in detail the tools and mediums that work best for paper collage and shows you how to set up your work space. Using the materials described, follow the basic collage procedures given step-by-step on page 26. You'll have the satisfaction of knowing your collages are well-crafted and can be exhibited without fear that they will self-destruct. Record in a journal the techniques you've used and ideas you want to try in the future. Get serious—but don't stop having fun!

PREPARING YOUR WORK AREA

The first step is to find a corner where you can get messy and leave things undisturbed—perhaps in the basement or utility room. Protect the floor with a plastic or canvas drop cloth. Set up a card table or a board or sheet of heavy plastic on a table or countertop to serve as the base of your work surface.

The work surface must be waterproof, leakproof and easy to clean. First, cover it with layers of

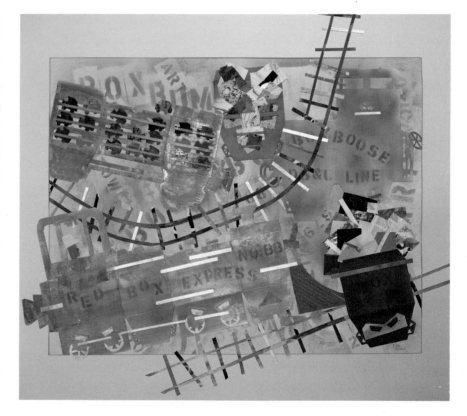

RED BOX EXPRESS by Delda Skinner. Multi media with boxes, airbrushed and marbled papers and acrylics on illustration board, 34"×41". Collection of Austin Thomas Vaughan.

How do they do it? Serious collage artists make it look easy. There is a spirit of fun and childlike abandon in this delightful piece, but Skinner carefully crafted the collage with quality materials so it will last.

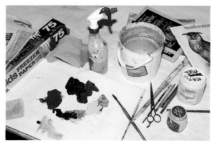

Cover your work area with coated freezer paper on top of newspapers. Have a large bucket of water and heavyweight paper towels on hand. Gather all your materials together before you begin working.

Acrylic Mediums

MEDIUM	CONSISTENCY	TRANSPARENCY	FINISH	TEXTURE	USE
matte medium	syrupy	transparent; translucent in multiple layers	flat; for papers and photos	no	excellent adhesive
matte medium & varnish	syrupy	transparent; translucent in multiple layers	satiny; reduces gloss	no	adhesive; satiny finish
gloss medium & varnish	syrupy	transparent	medium high gloss; dries crystal clear	no	adhesive; protective coating; paint extender
gel medium	creamy; heavy body	transparent	very high gloss; dries clear	yes	excellent adhesive for papers and objects; paint extender
matte gel medium	creamy; very thick	translucent	flat (flattens color)	yes	excellent adhesive for papers and objects
heavy gel	very thick; holds shape	transparent	very high gloss (enriches color)	yes	paint extender; textures
gelex	very thick; holds peak; flexible	opaque	flat	yes	paint extender; textures
modeling paste	very thick	opaque	flat	heavy; very hard	textures; mix with gel
gesso	thick	opaque white or colors	flat	yes	coating supports; adds tooth

newspaper to cushion it and to ensure that your glues and paints won't leak through to the table. Lay heavy, plastic-coated freezer paper (available in the canning section or the paper products aisle at grocery or discount stores) on the newspaper, shiny side up so it covers the entire surface and wraps around the edges. Secure the freezer paper with masking tape on the underside of the work surface base. Join any seams with masking tape. As you work, you can wipe this surface clean with a damp cloth or paper towel, and it will last for a long time.

ACRYLIC MEDIUMS

Acrylic mediums play a triple role in paper collage: as an adhesive, a paint extender and a protective coating for the support, collage materials and the finished collage. Refer to the chart above for the specific uses of each medium.

Adhesives are an important consideration in paper collage. Rubber cement and white polymer household glues are not dependable, because they sometimes discolor other materials and they tend to deteriorate over time. The traditional material for adhering papers is wheat or rice starch paste; methyl cellulose wallpaper paste may also be used. The advantage of these pastes is that they are reversible, and can be dissolved and reapplied. However, they are not as versatile as acrylic mediums, which we prefer because they are water-soluble when wet and form a permanent plastic film when dry.

Brush samples of different mediums on a variety of surfaces for reference. Label the samples as to type of medium and brand name. Experiment with some of the newer products that come on the market from time to time, as well.

Keep records of your experiments. Pick one you like and use it in a collage as the adhesive or paint extender. You'll like some better than others, and as you become more experienced with acrylic mediums, you'll find you can use many of them interchangeably. Get in the habit of lightly coating the outside neck of the medium jars with Vaseline to prevent lids from sticking, but don't get Vaseline in the medium itself.

Acrylic mediums have excellent adhesion. Acrylic matte medium adheres most papers and dries without a shine. You should use matte gel for adhering heavy papers, cardboard or objects. Blend acrylic modeling paste half-and-half with gel medium to prevent the paste from cracking as it dries, and use this mixture for adhering extremely heavy materials and objects. Do your own experiments with a variety of mediums and materials.

Most surfaces used for collage require a coating of acrylic medium to protect them from damage caused by acidic materials, such as newspapers and wood fragments. Treating these acidic materials themselves with an acrylic coating offers further protection. A final treatment of the collage with a coat of gloss medium or gel helps to seal the col-

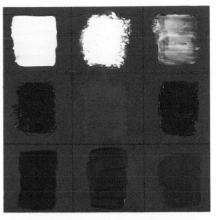

Here is a sampler of mediums (left to right). Row 1: matte medium (flat); matte medium and varnish (satin); gloss medium and varnish (high gloss). Row 2: gel medium (high gloss); matte gel medium (flat); heavy gel (high gloss). Row 3: Gelex (flat); modeling paste (flat); gesso (flat). The text on this page describes how to use these mediums.

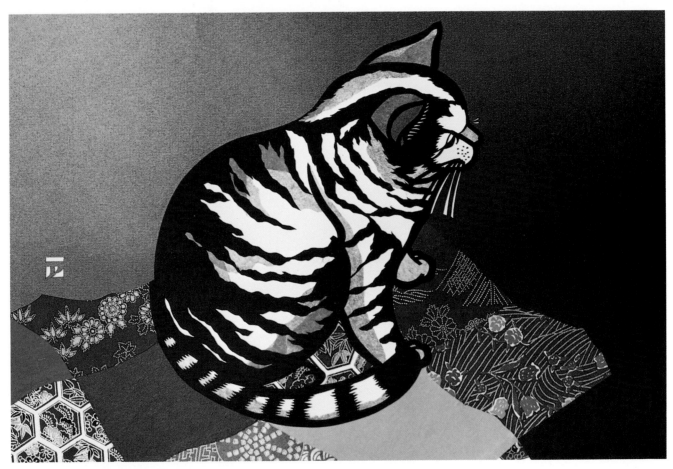

KITTY ON THE BLANKET by Aki Sogabe. Cut paper collage, 16" × 20". Private collection.
This cut paper collage was adhered with acid-free paste, an adhesive that will not cause paper to deteriorate or discolor.

lage from damage by light and pollution. You'll find more information on conservation of collages later in this chapter and in chapter fifteen.

To achieve the paint consistency you desire without diluting the brilliance of the color, add one of the acrylic mediums. All acrylic mediums can be mixed with water-based colors, although best results are achieved with acrylic paints. Although watercolors tend to crawl on surfaces treated with acrylic mediums, a drop or two of a "flow improver" such as ox gall in your water modifies this effect.

Combine mediums for different effects; for example, adhere papers with matte medium, then use textured matte gel to bond natural materials like leaves and shells to the same collage. You can also add iridescent and interference mediums to your paints to impart a pearl-like shine to the paint colors. If you plan to have your artwork reproduced, be aware that these mediums do not always reproduce reliably. Mix retarders with your paints and mediums to slow drying, if you wish.

Use gloss medium or gel as a protective coating over your finished collage, followed by matte varnish to reduce shine. Gloss medium intensifies color, while matte medium slightly reduces intensity. A matte finish is preferable if you need to photograph your work. Use either Liquitex Soluvar Varnish or Golden Polymer Varnish as a final coat. Although coating will extend the life of non-archival materials, it is best to use all rag or pH neutral supports and materials for collage wherever possible.

BRUSHES

Apply thinner mediums, such as matte or gloss mediums, with a ¾-inch synthetic flat one-stroke brush. Use a stiff bristle brush for gels and pastes. A no. 8 synthetic round brush works best to apply medium to small pieces. You can add other brushes as you need them. It's vital to keep your brushes moist while you're working, either resting in the medium or in a jar of water; otherwise, if the medium dries on a brush it will be useless. Rinse your brushes well when you're finished and wash them thoroughly with heavy-duty liquid dishwashing detergent and water.

SUPPORTS

The support is the paper or board on which you paint or to which you adhere collage materials. At this stage you should upgrade to medium-weight illustration board (any color, any texture), stretched canvas, or canvas board from the

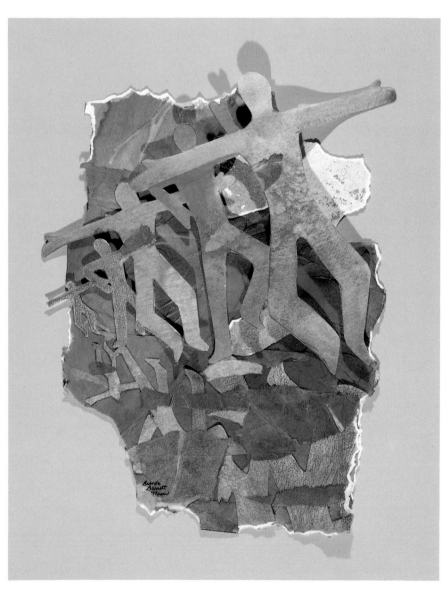

WATER DANCE by Brenda Barrett Mason. Watercolor and Prismacolor pencils on paper, 14″ × 13″.

When pH neutral papers are used, watercolor/collage combinations do not need to be encased in medium, because they are generally protected by glass. The quality of the paper makes the artwork more durable.

art store. The chart on page 86 lists other options.

Proper preparation of a support minimizes warping and prevents deterioration. You should coat both sides of a support, except for canvas, which you can buy already coated with gesso. Brush gloss medium on the support in crosshatch strokes. Always let a coated support dry thoroughly. Prepare several boards at once and store them, dusting the surfaces lightly with cornstarch to prevent them from sticking together.

MISCELLANEOUS MATERIALS

Stock plenty of coated freezer paper for your work surface (and also to use as a palette for acrylic mediums and paints), masking tape, water, newspapers, industrial-weight paper towels (for example, Scott "Shop Towels on a Roll"), which can be rinsed out and used repeatedly, or clean, soft cloths. Also, collect several different sizes of scissors, and keep them sharp. A brayer is useful for rolling out air pockets underneath collage papers. See sidebar above for guidelines for making a brayer.

To speed up drying of a collage, use a hair dryer on it. If you have space, hang a couple of inexpensive hair dryers over your work area so you don't have to hold them. See the illustration below.

Your hands will probably get pretty sticky, but acrylic mediums are relatively easy to remove from your skin. If your skin is sensitive, use thin plastic gloves or protect your hands with a non-greasy cream or lotion. Use a kitchen sponge-scrubber with warm water to remove acrylic mediums from your hands when you clean up. Wear your grubbies when you work. If you splash acrylics on your clothing, rinse off immediately in lukewarm water, or sponge with rubbing alcohol and machine wash in hot water.

CONSERVATION OF YOUR COLLAGES

Newspapers, magazines and inexpensive papers tend to deteriorate, becoming brittle or turning yellow. When you use these materials, extend the life of your collage by encasing your papers in gloss medium. Also, a final coat of matte medium or varnish on the collage cuts down on glare. This procedure helps to protect quality papers and prevents some inks from fading. Fine art materials like watercolor and rice papers hold up without coating, because they are usually framed under glass.

Use magazines and newspapers that are printed on heavy paper. *National Geographic, Connoisseur, Vogue, House Beautiful* and quality art magazines, calendars or appointment books are some of the better ones. Place a sample page in a sunny window for several weeks, with a control sample in a dark location, to test for fading (lightfastness). The heavier and slicker the page, the easier the material is to handle and the longer it will last. Thin washes of water media will bead up on the heavily coated or varnished illustrations, but thicker applications of acrylic paint will adhere nicely. Experiment to see which works best for you.

Avoid papers used in cheap printing processes, which incorporate inks that fade quickly, for example, inexpensive calendars and greeting cards. Also, avoid colored tissue papers, which aren't consistently lightfast. Ask your supplier about lightfastness of papers, or test them yourself.

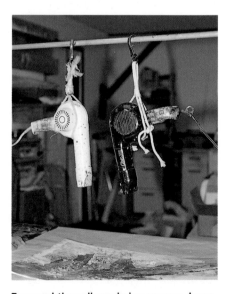

To speed the collage drying process, hang two hair dryers from a rod over your work surface. Rest the rod on brackets attached to poles at each side of the work space. The rod may be raised or lowered, as needed, and the dryers left running on low until the collage is dry. It's nice to have your hands free as the dryers blow the artwork.

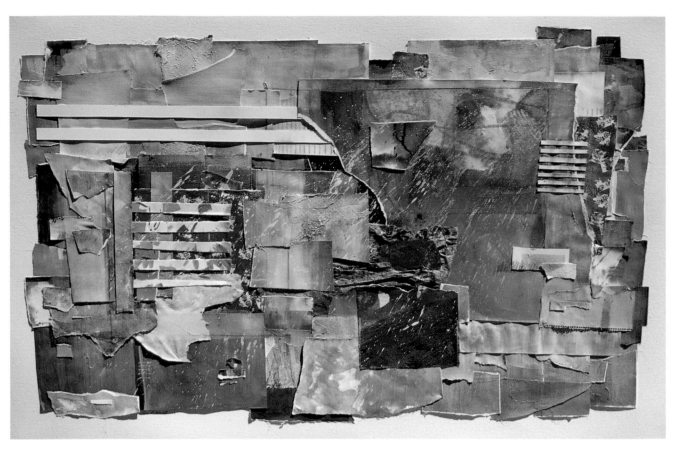

A MAY HAPPENING by Edwin H. Wordell. Water media and pencil on rag papers, 40" × 60".

No matter how many pieces go into your collage, the process is pretty much the same. To make a piece like this absolutely secure, use good materials and follow the basic steps described on this page.

Basic Steps in Creating a Collage

Five simple steps make up the collage process. Additional steps will be described later, but for now, follow these steps for every collage you do:

1. Coat the paper or board on both sides with undiluted gloss medium or gel thinned 50/50 with water. Let it dry. Coat the support again with matte medium and let dry.
2. Arrange collage pieces and adhere them with matte medium. Wipe off excess medium as you go and let dry.
3. Seal the completed collage with a coat of gloss medium or gel. Dry thoroughly. Weight down to flatten.
4. To reduce shine, or prior to photography, coat the collage with matte varnish or Soluvar and let dry.
5. Before storing, dust the finished collage lightly with cornstarch.

PROJECT SEVEN: Encasing Papers in Medium

Many papers used in collages are not acid-free and need protection so the collage will last. To do this, brush the back of a small piece of paper with a generous coat of gloss medium or thinned gel, place it on the support to adhere it, then brush another coat of gloss medium on the front of the paper to seal it. To encase papers and store them for later use, coat one side and let dry, then peel the piece from the freezer paper and coat the other side. Dust the pieces lightly with cornstarch when they are dry, to prevent bonding. Store in a cool, dry location. Separate the pieces occasionally.

For this project, you will experiment with encasing paper. This will give you some practice using gloss medium to coat collage materials. Here's an easy one to begin with. Dampen sheets of typing paper, then crumple them to create a network of veins throughout the paper. Stain the paper by dropping lightfast colored inks or transparent watercolors from a round brush onto the dampened paper. Spray with water to keep the colors moving. When dry, coat both sides of the paper with thin applications of gloss medium. Place the encased paper on the waxy side of freezer paper to dry, lifting occasionally to prevent sticking. The coated paper is slightly translucent, with darker colors in the veins. Use torn pieces of encased paper in a collage, arranging and adhering as described in the "Basic Steps in Creating a Collage" sidebar on page 26.

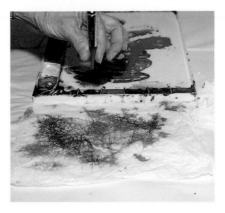

Here is one easy encasing technique. First, drip or paint watercolors or acrylics on crumpled typing paper. The paint will crawl into the veins of the paper, creating a batik effect.

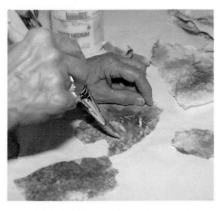

Tear the painted paper into pieces and coat them with gloss medium on both sides. Let dry and arrange in a collage.

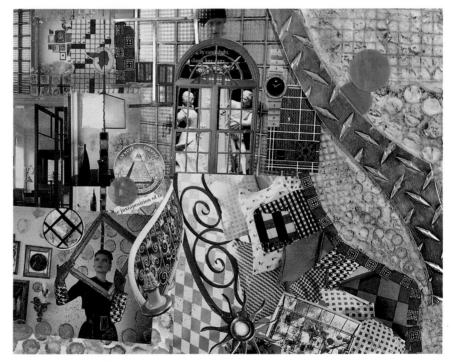

PATTERNS OF SQUARES AND CIRCLES by Virginia Lee Williams. Cut and torn magazine papers with shaped metal on illustration board, 15" × 20".

This active design is made up mostly of magazine papers. To assure that the collage will last, the support was coated with gloss medium and the finished piece "encased," that is, coated with one coat of gloss medium and a final coat of matte medium.

PROJECT EIGHT: Creating a Transfer Film

Here's another project with acrylic mediums that is easy and fun and that produces an acrylic film onto which you transfer a picture from a magazine. First, coat a magazine picture, on the front only, with five coats of acrylic gloss medium, drying each coat thoroughly. Let the picture dry overnight, then soak it in warm water for fifteen to thirty minutes and peel or rub the paper gently from the back of the acrylic film. Resoak and rub off any paper that continues to cling. The ink remains on the film. Some magazine inks will transfer more easily than others. Experiment.

To use a piece of transfer film in a collage, brush gloss medium or gel on both sides of illustration board or 140 lb. cold-press watercolor paper. When dry, brush on a heavy coat of matte medium. Place the film, ink side down, on the still wet medium and roll with your brayer. Let stand ten to fifteen minutes. Don't use a hair dryer to speed the process. Peel back a corner of the picture to see if it is transferring. If not, wait a few more minutes. Peel off the film. A ghost image remains on the board, and some may also remain on the acrylic film.

You can transfer several ghost images to your board using the same piece of film if any image remains on it. Adhere the film to the board, overlapping earlier applications and making interesting juxtapositions. To fasten the film to the collage permanently, brush matte medium on the support, place the transfer on the wet medium, and pat down or roll gently with a brayer. Dry, then finish with a coat of matte medium to reduce shine. Add paper collage, if desired.

To create a transfer film of a magazine picture, coat the image side of the clipping with five coats of gloss medium, drying each coat thoroughly.

Soak the clipping in warm water and carefully rub the back with your finger to remove the paper from the coated image. Only the ink will remain on the transfer film.

Place the film, ink side down, on a heavy layer of wet matte medium. Let stand ten to fifteen minutes, until the image transfers, then carefully pull off the film.

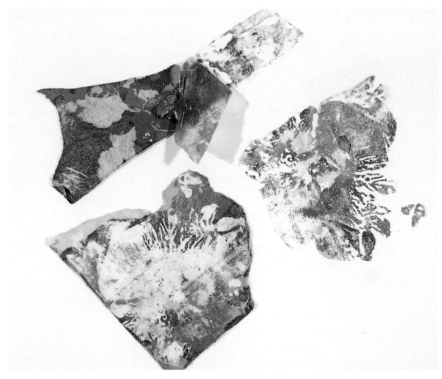
Starting with the top left image, and moving clockwise, you can see the transferring process of a piece of film, a transferred image, and a piece of adhered film.

CHAPTER FOUR

Landscapes and Portraits

This chapter introduces exciting new ways to use newspapers and magazines in collage, beyond simply clipping pictures and words to illustrate a theme. You'll learn to make pictures with newspaper clippings and to describe form in color using magazine clippings. You can combine printed materials in many intriguing ways. Think of words, letters and snippets of color as your palette, selecting colors and values as you would with paints, then designing landscapes, portraits or still lifes.

Here are some of the things you can do in collage with newspapers and magazines: arrange columns of type, advertisements or printed boxes to suggest a cityscape or other architectural subject that is characteristically blocky or rigid; use a fashion magazine, selecting the flowing lines of richly colored

THE APPLE by Bob Kilvert. Paper collage, 32" × 45". Private collection.

Bits of color, texture and value can be arranged in such a way that they suggest painterly brushstrokes. The basic collage technique of pasted papers is masterfully applied here to depict the figure and landscape.

fabric photos for an organic abstraction or a landscape; cut and tear colored pieces from magazine ads and use them like small brushstrokes to develop shapes and contours of objects. As you read magazines or newspapers, search for unusual and colorful printed matter. Whenever a clipping intrigues you, cut it out and save it for later. The larger your collection is, the more distinctive your collages can be, with unusual juxtapositions and bizarre combinations of materials.

Prepare your work area as described in the previous chapter, protecting the surface and having mediums and tools ready. Use a support that you have already coated with gloss medium on both sides. Plan your subject and collect a variety of printed materials that relate to it. Start with a general idea for the arrangement, but be prepared to change your mind as you move your materials around. Follow the basic collage procedure: adhere pieces; wipe clean with a damp cloth. Dry, then coat the entire collage with gloss medium. For low shine, brush on an additional coat of matte varnish.

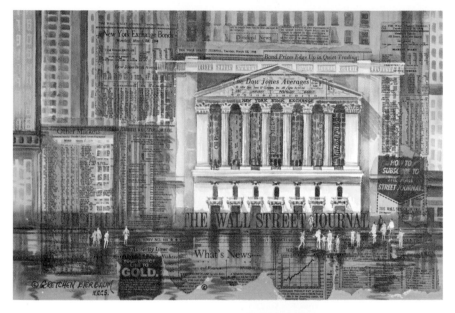

This color wheel shows how magazine clippings are your palette, just like paint colors are a painter's palette. Every color of the spectrum is at your scissor-tips.

(Above)
WALL STREET by Gretchen Bierbaum. Watercolor and newspaper collage, 13″ × 21″.

This newspaper collage is a striking image. With all printed material related to a theme, the piece is cohesive. Washes and opaque brushstrokes representing figures bring the architectural subject to life.

(Right)
YELLOW POLKA DOT BIKINI by Pat Clark. Paper collage, 13½″ × 15½″.

Your collage doesn't have to be complicated even with people in it. With tongue in cheek, put a familiar image in an unfamiliar setting to make an amusing piece. In this case, Clark has cut out complete images and put them together in a landscape background.

PROJECT NINE: Using Newspapers in a Landscape Collage

The linear quality of typeset newspaper pages lends itself well to landscape imagery. Start by choosing a landscape subject: skyscrapers, houses, farm buildings. Cut out or tear visually interesting pieces of newspaper. Think mainly of the visual effect of the column or box shapes; vary textures as you begin to develop your layout of the larger pieces.

As you arrange the cut or torn pieces on a white background, place your greatest contrasts of light and dark so they attract the viewer's eye to a specific area of interest. Remember to squint your eyes occasionally, so you can see these contrasts. Lay the collage on the floor and stand away from it to get a better look at the impact of the arrangement. If you want to look at a collage before you fasten the pieces down permanently, cut a 1-inch piece of low-tack drafting or artist's tape or removable Scotch tape; roll it into a circular shape so the ends join with the sticky side out. Stick the tape to the back of the un-adhered collage pieces and press lightly to the board. Remove the tape before adhering each piece.

Introduce plain, unpatterned areas at intervals to give the viewer's eye a place to rest or let the support show through. Take your time working out different compositions. When you like what you see, brush matte medium on the entire back of each clipping and adhere it to a support that you have coated on both sides with acrylic gloss medium.

Tear out additional pieces to represent other elements, such as clouds, trees, people and plants, to liven up your picture. The torn edges of the pieces are suited to these organic objects. Add printed words to contribute humor or poignancy or to create a sense of a specific place in your landscape.

After everything is bonded to the support and thoroughly dry, brush one or two thin coats of gloss medium (let each coat dry thoroughly) over the entire surface to preserve the paper; add a coat of matte medium or varnish to create a consistent matte appearance. The completed collage is now entirely encased in medium and protected from deterioration. Let the collage air dry or use your hair dryer.

Here are more ideas for print collages: Create a business-related collage using the *Wall Street Journal* stock quotations, or city newspaper banners and headlines to depict a skyline of the city. Create a style statement with fashion drawings from retail ads. Make a political statement or social satire, using type combined with political cartoons and caricatures.

THE COTTAGE by Hilda Hull. Newspaper collage, 8½" × 11½".

This student has captured the essence of this landscape subject using newspaper to represent the textures of tree foliage, fence and cottage detailing. The design shapes from ads relieve the monotony of type.

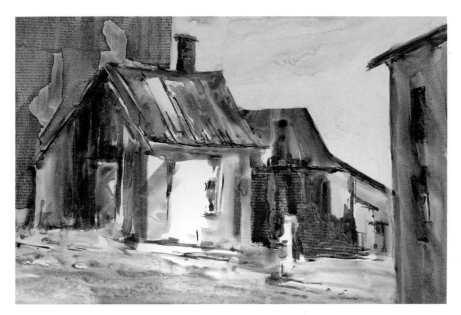

THE ALLEY by Nita Leland. Watercolor and paper collage on illustration board, 15" × 20". Courtesy of Norma and Al Jones.

Newspaper adhered to a watercolor, then tinted and sponged lightly to smudge the print, gives a textured appearance to a crumbling wall. The newspaper is used only for its texture and not for any theme or meaning of the text.

PROJECT TEN: Creating Form With Magazine Clippings

In this project you will suggest the form of an object by using bits and pieces of cut or torn magazine pictures. Ask friends for their magazines, such as *Architectural Digest*, *National Geographic*, *Vogue* or *Art in America*. Gather an assortment of color and texture clippings from these good quality magazines. This is your color palette. Use your favorite colors and pick out many variations of the colors, light and dark, bright and dull. Trust your instincts and just play with the colors. Save leftover colors and textures, filing them with your found papers for future use.

Choose bits of color and texture to represent different areas of the object you plan to depict. Ask yourself: Where are the light areas? The shadows? The textures? Find clippings to represent these areas. Cut or tear many small pieces to fit the shapes of the areas. For example, to depict an apple, collect bits of red, green and yellow in a range of light and dark values from your colored magazine pictures and arrange these pieces to suggest the highlights and shadows of the apple, making colored shapes that follow the curving form of the apple. Remember, for hard edges, cut the clippings, and for soft edges, tear them.

The procedure for securing the pieces is to (1) plan your design, (2) arrange and fasten the larger pieces onto a prepared support with medium, (3) then attach the smaller pieces. To keep from getting confused about where the pieces belong, before you move them to apply adhesive, trace around the edges of each piece with a pencil to mark its placement. As you set the piece aside, mark the back with a number corresponding to a number on the underlying piece or on the support. Adhere the highest numbers first, finishing with number one.

To soften areas or create an antique patina, rub dampened areas lightly with a sponge to wear away the ink. Encase the completed collage with one coat of gloss medium and a final coat of matte varnish.

Arrange cuttings from magazines to represent light and dark areas of a simple subject. Carefully mark the placement of the pieces. Things get jumbled easily when you're working with so many little bits. If you need to, number the pieces and the support and "collage-by-number."

Adhere several small bits to a larger piece, then put the entire arrangement in place on the collage.

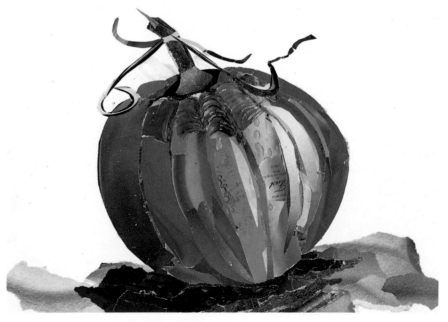

CINDERELLA'S COACH by Virginia Lee Williams. 10" × 12½".

With a suitable selection of colored magazine cuttings, you can create a sense of light and shadow that suggests form.

PROJECT ELEVEN: Making a Portrait Collage

You'll be surprised at how easy it is to do a portrait collage. You need a fairly broad palette of colors in your envelope filing system to begin with. If necessary, expand your collection of colored clippings from a large selection of good-quality magazines so you won't have to stop and search through your magazines for every color as you develop your collage. Make a special file of flesh tones from dark to light, using vibrant colors and rich darks.

Sketch the portrait lightly on illustration board or heavy-weight paper, indicating value changes and colors right on the board. Tear pieces of magazine into small pieces and arrange in the appropriate areas, building the form and likeness with changes in value and color. For example, work with magazine illustrations having a lot of peach, creamy yellow, orange and red in them, using the lighter colors for highlights and the darker shades for shadows. For darker-skinned races select a range of colors from golden yellow through reds, browns, greens and violets. Gradually create facial features, adding small bits of color to the basic shapes of lips, eyes, nose and ears. Keep adding pieces till you get what you want.

Utilize interesting textures from your clippings to represent skin, hair and clothing. If the color is right, you can usually disregard any words on the piece, as long as they aren't terribly distracting or inappropriate. Take your time. The building-up process may take awhile, but your patience will be rewarded.

Enhance the portrait with a col-laged background, using colors that harmonize with the portrait colors.

As you can see, it's easy to get started in collage. All you need are a few magazines or newspapers, a support, and matte and gloss medium.

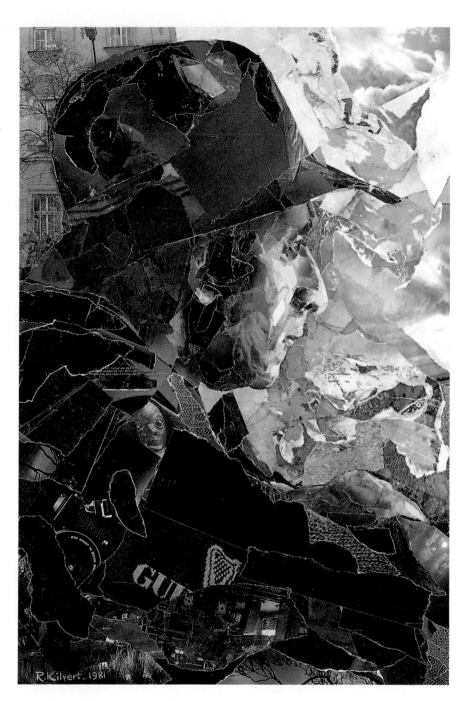

THE BLACK FELT HAT by Bob Kilvert. Paper collage, 22″ × 15″. Private collection.

This collage is a fine example of the use of form and value. Notice how torn collage pieces follow the shape of the shoulder and the hat, while impressive value contrasts around the face add drama and emphasis. Paper highlights on the cheek and hat add brilliance.

DEMONSTRATION ONE: Combining Basic Collage Processes

This demonstration shows you step by step how to make a complete collage from start to finish. The techniques and ideas are drawn from the simpler projects you have just completed in part two. We thought it would be fun to use chickens as our subject. In addition to magazine papers, wallpaper, fabric samples and feathers, we made rubbings (see page 6) and transferred acrylic film (see page 28) with a couple of nifty pictures we found. We decided to emphasize patterns as the theme in this piece, because of the availability of so many beautiful magazine ads.

STEP ONE. First, we coated the board on both sides with matte medium. After it was dry, we drew our subject carefully on the board. The background will be kept simple, because the collage materials are patterned and very busy.

STEP TWO. A delightful array of patterned collage materials was gathered, along with a few bits that relate to the "chicken" theme—pebbled wallpaper for corn, a magazine picture of stones that resemble eggs, and a couple of chicken images. We also texturized a piece of paper with rubbings using a pink pencil over a grid with a circular pattern on it (shown on bottom half of the finished collage).

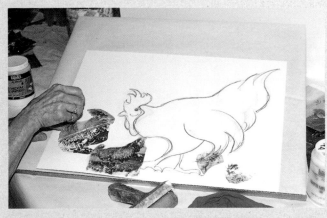

STEP THREE. The chicken images were coated with five layers of gloss medium. After the last layer of medium had dried, the images were soaked for fifteen to twenty minutes and the paper backing rubbed off, leaving a transfer film. The transfer was placed ink-side-down on wet matte medium on the support and was rolled with a brayer. After ten to fifteen minutes, the transfer film was peeled up, leaving the chicken images on the support.

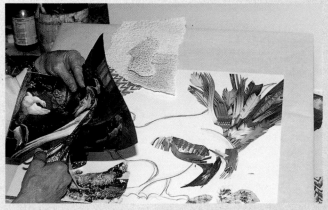

STEP FOUR. We began adding cut-paper collage, filling in small spaces. It was lots of fun finding just the right color or texture for each area. After we selected the most important areas, such as the tail and wing, we trimmed the pieces and put them in place without adhering, to get a general idea of the overall effect.

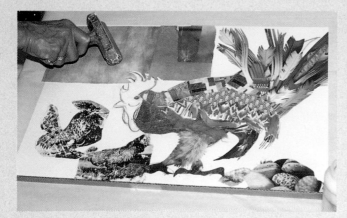

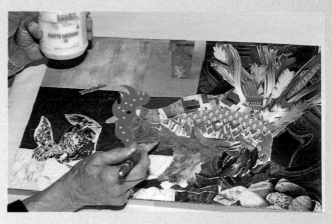

STEP FIVE. When we were satisfied with the placement of the pieces, we marked around the edges and began adhering them. We used a brayer to roll the pieces flat on the support. Then we began the same process with another section of the collage, keeping a sharp eye on how the colors and patterns played against each other and against the background.

STEP SIX. After all the pieces on the chicken were secured, we completed the background in simple, dark shapes and colors to emphasize the rich patterns on the rooster. We used tracing paper to outline the intricate feathers on the tail and transferred the shape to a colored background piece, then cut it out and adhered it. The final step was encasing the collage beneath two layers of medium, first gloss, then matte, to seal the collaged papers and protect them from deterioration.

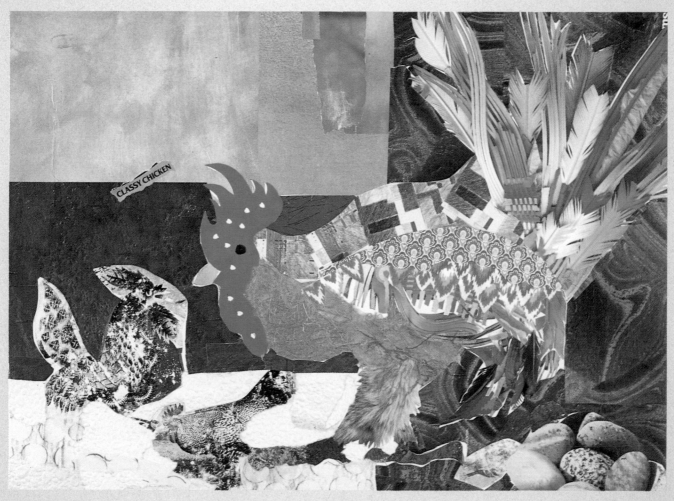

CLASSY CHICKEN by Nita Leland and Virginia Lee Williams. Paper collage, 15" × 20".

THE FLUTE PLAYER by Wilcke H. Smith. Stitchery assemblage with polymer clay and mixed media, 9" × 12" × 1⅛". Collection of Eby Wold.

Use the elements and principles of design as foundations for planning and creating dynamic collages, both realistic and abstract.

CHAPTER FIVE

Design and Color

Paper collage doesn't require mastery of drawing or painting skills. What a concept! Still, as a collage artist you need to understand design fundamentals to create unity from the jumble of materials available.

Don't tie yourself down to obeying rules, though. The rules are meant to get you started or bail you out when your inspiration fades. They keep you in the game until your creativity flourishes once more. Use the rules as guides in planning and as checkpoints for discovering strengths and weaknesses in your artwork.

Although many collage artists begin without a predetermined direction, it usually helps to have a

AMERICAN MACHINE by Jonathan Talbot. Paper, foil, paint and ink transfer, 14½″ × 24″. Collection of Yvonne and Peter Gilpatrick.

Talbot brought order to the chaos of materials and created a crisp, intriguing work of art through his intelligent use of design elements and principles. He achieves unity through the repetition, with variation, of design shapes and the dominance of powerful value contrast in this nearly monochromatic collage.

"AMERICAN MACHINE"

concept, a main idea or feeling that you want to convey. Then select the design factors that best support that expression. For example, to express the serenity of a marshland in a semiabstract collage, emphasize dominant horizontal lines and large, simple shapes, using harmonious colors that are near each other on the color wheel, with just a touch of contrast and texture. To express the energy of a stormy sea, use powerful diagonals, dominant greens and blue-greens, wave patterns and rhythmical brushstrokes.

Making collages is a little like packing for a trip. First, you lay out everything you think you want to take along, then you simplify, organize, coordinate and leave half of what you laid out at home. Gather lots of materials, then eliminate some as you zero in on your collage idea.

The elements of design are line, shape, value, color, movement, size and pattern. You unify these by applying the principles of design: harmony, contrast, rhythm, repetition, gradation, balance and dominance. This chapter describes these elements and principles in detail.

Don't panic! You have been designing from the very first collage you made, when you unified your design with a theme or a few words of type. Design fundamentals make your pictures work. Learn them well. Post the list of elements and principles of design (on pages 40-41) near your work area and use it as a reference. Eventually, design knowledge will come easily to you.

You learn design by doing.

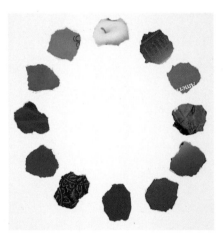

Learn the relationships of colors on the color wheel and you'll soon be a color expert. Magazine clippings provide you with every color of the spectrum. Make a color wheel like this one to familiarize yourself with the placement of the colors around the wheel.

COALESCENCE by Delda Skinner. Mixed media with acrylic, watercolor, rice paper, handmade paper and bark paper, pencils and stamps, including the techniques of collage, frottage and monoprint, 22" × 21". Courtesy of Spicewood Gallery, Austin, Texas.

Color dominates this dazzling piece with strong contrast of pure, high-intensity hues and warm (red) and cool (blue) temperature contrast. Unity is partially a result of the subtle repetition-with-variation of handprints colors and textures. The figurative elements lend an air of mystery to the abstract design.

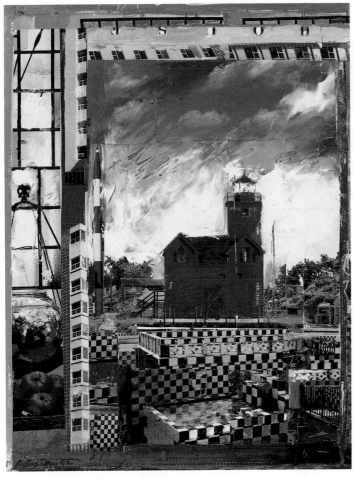

SEA HOUSE by Arless Day. Collage on board, 16⁵⁄₁₆" × 11⁷⁄₈". Courtesy of Jerald Melberg Gallery, Inc., Charlotte, North Carolina.

Design is equally important in a vibrantly colored piece. It takes knowledge, skill and practice to unify diverse collage materials and patterns and integrate them with painterly and gestural effects. The dominant hue (blue) and repeated checkerboard pattern are unifying elements.

SACRED PLACES II by Valaida D'Alessio. Watercolor, inks and colored pencils on torn watercolor and rice papers, 11" × 15".

After cutting and tearing painted watercolor papers into interesting shapes, the artist then arranged them as the dominant elements in this dynamic abstract design. Subtle color and pattern are also elements of the design.

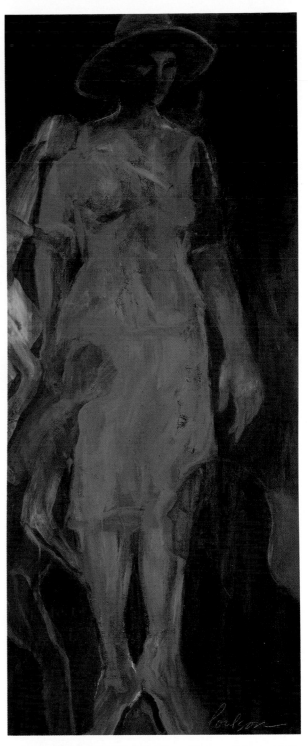

SHROUDED FIGURE by Karen Poulson. Tissue collage support, acrylic paint, on Gatorfoam board, 58" × 23".

With a powerful value and color treatment, Poulson painted into a support that she prepared with tissue paper collage, creating a strong figurative piece in a simple, elongated format. Design doesn't have to be complicated. It just has to be good.

The Elements of Design

Lines define boundaries, make connections and describe contours. In collage line is often a surface element rather than a structural one, as it might be in a painting or drawing. String, ribbon and other fibers or small twigs can be used to create linear rhythms.

Shape is the foundation element in collage. The arrangement of cut (geometric) or torn (organic) papers into larger design shapes establishes the power of the image. Maintain the integrity of the shapes as you develop your collage, arranging your collage materials to strengthen the basic shapes.

Value refers to light and dark contrast on a scale which moves from white through gray to black. Create visual strength with strong contrasts, using high-key, light values for upbeat feelings and low-key, dark values for somber moods such as despair.

Color has tremendous expressive potential in collage as in any art medium. There are no absolutes in the use of color. Honor your personal responses to color, but be sure you have a foundation of color theory to support your intuition. Random selection of colors is risky in collage because there are frequently such diverse materials involved that it's easy to lose color dominance and destroy the expressive impact of the collage. Read the special section on color on page 44.

Movement means energy and direction. Direct the viewer's eye around the picture and control the speed of movement. Horizontal movement is calm; vertical is stable; oblique is energetic. Arrange your collage pieces so they emphasize a dominant direction, then add counter-movements for contrast, such as a meandering diagonal that enlivens a static horizontal composition.

Size contrast is a useful element. Begin with large pieces to establish a basic design and embellish it with small pieces to suggest significant detail in a realistic subject. Combine small pieces to build large shapes, using them to enhance the big shapes in a decorative manner without detracting from the importance of the shapes.

Pattern refers to texture, and to the visual patterns you create on the support through the repetition of lines, values, shapes and colors. The viewer's eye follows these patterns—distinctive colors, flickers of dark values on flashes of white—throughout the composition. You have absolute control over this response.

The elements of design are the tools with which you construct the framework for your collage. Your choice of design elements integrates your collage materials with your subject and the emotional content of your work and, ultimately, defines your artistic style.

Line

Shape

Value

Color

Movement

Size

Pattern

The Principles of Design

Harmony occurs when your design has similar elements that express serenity and calm. Create harmony by selecting adjacent colors on the color wheel, basing a composition on similar geometric shapes, or using a narrow value range.

Contrast, which keeps your picture from becoming boring, is based on differences between elements. For example, add energetic diagonals to a placid, horizontal composition or inject a strong value or color to increase visual entertainment.

Rhythm is created when the spaces between shapes and colors create a cadence in the movement through the picture. Evenly spaced objects are sedate. A syncopated, irregular rhythm creates excitement. Sometimes you want to waltz, sometimes you want to boogie.

Repetition creates movement and moves the eye around the picture. Repeat materials, shapes, colors and directions with several variations.

Gradation is the gradual change of any element of design, which provides transition between areas of the design and contributes to the movement in the picture. You can gradually change color temperature from warm to cool, soften a jagged line to a gentle curve, or round off the corners of a square and change it into a circle.

Balance is intuitively felt. Move the pieces and objects, adding and subtracting them till the design works for you. A symmetrical design is evenly divided. An asymmetrical design has unequal elements distributed according to visual weight.

Dominance unifies your design. One design element must be more important than the others; one of the design principles must rule. Dominance resolves conflict among elements: one piece is bigger than another, one shape is repeated, one color is more intense than others.

Unity is the ultimate objective of design. When you have organized all of the fragments of paper and objects into a cohesive whole, whether it is serene or energetic, you have a unified design. Several elements of design may be involved in a single picture, but they are integrated so they create a meaningful visual expression with a sense of completeness about it.

Harmony

Contrast

Rhythm

Repetition

Gradation

Balance

Dominance

The principles of design are the rules that you apply to the elements of design to organize your collage into a unified whole. You select design principles to reinforce the expressive idea you wish to communicate and rely on dominance of one element or principle to establish unity.

PROJECT TWELVE: Making Design Charts

As a way to develop your design awareness, create your own design charts like those on the following pages. Play with different combinations of shape, size, color and so on; once you become familiar and comfortable with the elements and principles of design, you'll find yourself mixing and matching them quite easily in your collages. Nearly all of them will appear in every collage, but your choice of which ones are the most important will contribute to the sense of style in the piece.

Study the collages throughout this book. Which ones do you like best? Why do you like them? Identify the design elements and principles that make each piece distinctive. This will give you a better sense of which elements will work best in your own collages.

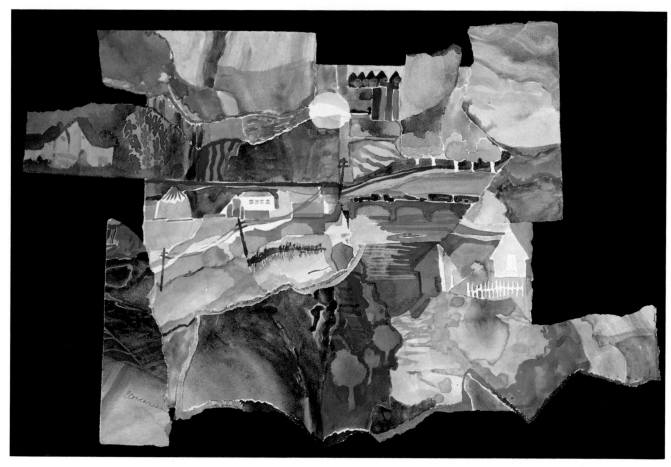

ILLINOIS SERIES: ON THE ROAD by Elizabeth Concannon. Watercolor collage on 300 lb. watercolor paper, 20" × 24".

The contrast of pure hues sets up wonderful color vibrations in this collage. The shape variations are particularly appealing as they move beyond the rectangular format. Related pictorial elements—barns, trees and other farm images—unify the composition.

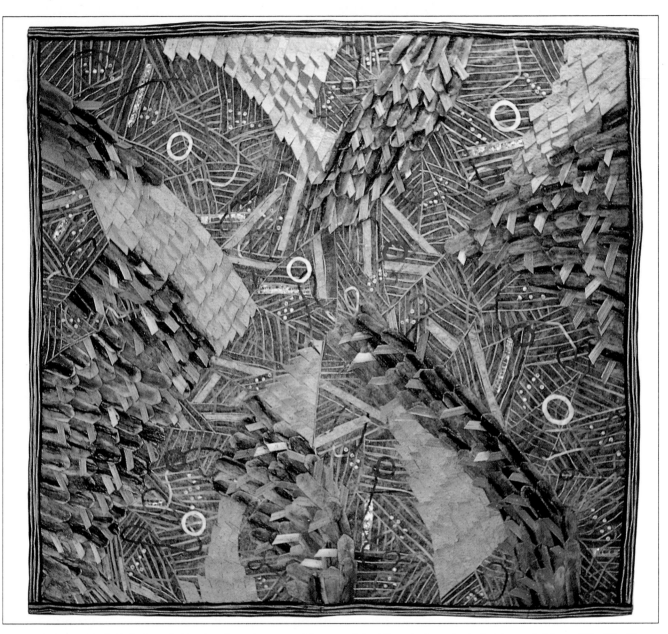

FLIGHT OF PHANTASY by Lois Dvorak. Handmade and commercial papers, felted flax, shells, palm leaf strips and ribbon, 42″ × 41″ × 2″. Private collection.

Repetition-with-variation of patterns and materials creates unity in this collage. The oblique thrust of the shapes suggests energy and movement. Color is understated, with just a few bright accents for contrast.

USING COLOR IN COLLAGE

Collage artists tend to work intuitively with color and you should trust your intuition. Familiarize yourself with the basics of color and develop your color perception and color awareness through practice. For more information on color see *Exploring Color* by Nita Leland (North Light Books).

Color Fundamentals

Color has four properties: *hue*, *value*, *intensity* and *temperature*. Use these to strengthen the focal point, unify the design, and enhance the expressive content of your collage.

Hue is the spectral name of the color: red, red-orange, orange, yellow-orange, etc.

Value is the lightness or darkness of a hue. A light value is a *tint* and a dark value is a *shade*.

Intensity, sometimes called *saturation* or *chroma*, indicates the brilliance or dullness of a hue, the result of introducing gray or the complementary (opposite) hue into a pure, bright color.

Temperature is the relative warmth or coolness of a hue. Any hue may seem warmer or cooler depending on what is next to it.

Color Schemes

Begin a collage by planning a color scheme based on a limited number of colors, from three to six hues.

Two common color schemes, based on similarities, are *monochromatic* (a single color, used in different values and intensities) and *analogous* (three to four hues that are adjacent on the color wheel). Five schemes based on differences are *triads* (any three hues with a balanced triangular relationship), *complements* (two hues that are opposite each other on the color wheel), *analogous complements* (three adjacent hues, plus the complement of one of the

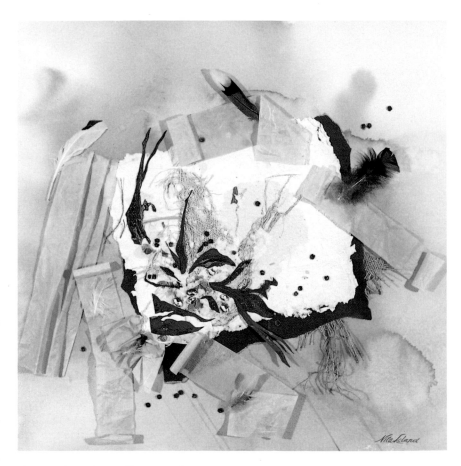

three hues), *split complements* (one hue plus the two hues on either side of its complement), and *double split complements* (two hues on each side of any hue, plus the complements of both hues).

Color schemes—the logical relationship of colors on the color wheel—enable you to enhance your collage design with distinctive color harmonies that have a broad range of expressive potential. You can use color in your collage with confidence, eliminating time-consuming trial-and-error by selecting a color scheme before you begin.

SIX LESSONS LEARNED by Nita Leland. Mixed media collage on watercolor board, 22″ × 22″.

The gradation of the analogous color scheme in this collage, from yellow to red-orange, contributes to a whirling motion.

PROJECT THIRTEEN: Monochromatic Collage

In this project you will make a monochromatic collage with a full value range (light to dark) and different intensities (bright to dull) of a single color. This simple color scheme teaches you to balance value and intensity relationships as you work with line, shape, pattern and so on. You can use any colored papers available, such as magazine illustrations or Color-Aid and Chromarama papers, which offer a fantastic selection of colors and values that you can use

for brilliant color accents in many of your collages. Although expensive, a single pack lasts a long time. Save your paper scraps in small plastic bags and file them according to color.

Plan a simple design and create a pattern of values in a single color. Cut or tear large shapes that are similar, but not identical to one another, adding smaller shapes to indicate one or more of the following: value contrast, size contrast or pattern repetition. Es-

tablish a dominant movement or direction.

Remember, the proper adhesive is important. Use matte medium, carefully wiping it off each piece with a damp cloth before it dries. Adhere the pieces to a support that has been coated on both sides with gloss medium. Coat the entire surface of the completed collage with one coat of gloss medium or thinned gel, allowing it to dry thoroughly before finishing with a coat of matte varnish, if desired.

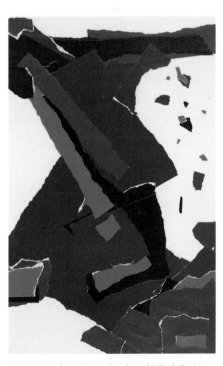

LA ROUGE by Nita Leland and Virginia Lee Williams. 14" × 9".

In this collage rectangular design shapes are repeated in a variety of sizes and values of a single color. The lightest and darkest values help to move the viewer's eye around the collage.

SEA FRAGMENTS by Jean Deemer. Acrylic and iridescent paint on hand-painted papers, marbled paper, gold cord, shells and iridescent cellophane on brayer-painted illustration board, 14" × 21".

A monochromatic color scheme is beautifully harmonious because there is no competition with another hue. A bit of value contrast is provided in the collage by the neutral black and flickers of iridescent color. The addition of the linear element adds a touch of surprise in what is essentially a shape collage.

PROJECT FOURTEEN: **Weaving Colored Papers**

Weaving colored papers together creates collages rich in color and texture. Combine colored papers and magazine illustrations, along with posters, old watercolors and wallpaper, with non-paper items such as fibers, ribbons, string and yarn. Select both solid and patterned materials with strong color dominance, which will unify the different colors and textures in the design. Cut your papers into strips of different widths.

To weave your materials together, lay the colorful arrangement of strips side by side, like columns, on a flat surface. This is your "warp." Tape one end of each strip to the surface with low-tack drafting tape or place the ends under the clip of a clipboard. Insert a strip first under, then over, the warp strips all the way across the row of columns. On the next row, slide a strip first over, then under, across the row. Insert ribbon or yarn, instead of paper strips, across some rows.

Vary the edges of the woven shape by using different lengths of colored strips or by trimming the edges in places. Adhere the woven piece as a focal point on a support that has been coated with matte medium. Add other collage materials, or tint the background with watercolor or acrylic washes.

CELEBRATION by Nita Leland and Virginia Lee Williams. 15″ × 10″.

Mount the finished woven piece to illustration board by coating the board with matte medium and placing the piece on the wet medium. Pat down or roll with a brayer.

To weave paper, lay out a row of colored paper strips of varying widths, side-by-side. Tape along one end to keep the strips from moving, then weave colored strips and lengths of ribbon or yarn through the row.

TRAVERSING SPACE by T. F. Poduska. Acrylics on 140 lb. Arches cold-press watercolor paper, 44¾″ × 86½″.

For this collage, Poduska first painted two completely different paintings. She then cut one painting vertically into equal-sized strips, and the other horizontally, also into equal-sized strips. Each strip was numbered so the artist could reassemble the paintings. The strips of one painting were secured on a grid with masking tape, and the other painting strips were tightly woven through it.

Using Ready-Made Papers

As you have discovered, newspapers and magazines aren't the only sources of materials for paper collage. There are many beautiful, high-quality papers available in art and school supply stores, some craft shops and by mail order. You can improve your design sense as you work with ready-made papers and create stunning collage works at the same time, combining colors and textures.

Ready-made papers should be acid-free or pH neutral, and their colors should be lightfast, if you want your collage to last. Quality papers will last longer than those from newspapers and magazines; however, even these papers should be encased with medium to assure permanence. Avoid colored tissue and construction papers, which may fade or deteriorate quickly.

Some of the papers you might use include oriental rice papers, Color-Aid, Chromarama, textured charcoal and pastel papers, tinted watercolor papers, marbled papers or printmaking papers. Remember that the different characteristics of papers (weight, texture, rigidity, etc.) call for different

Here are just a few of the ready-made papers found at art and craft stores: rice papers, Color-Aid or Chromarama and tinted pastel papers. You may also find marbled papers and handmade papers. Try everything. Your collage style may evolve as a result of your response to the texture or handling qualities of a particular paper.

DRAGON'S LAIR by Brian L. Dunning. Mixed media with tissue paper, cutouts, watercolor and photomontage, 4½" × 6".

Tissue paper overlay creates a glazing effect, similar to layers of transparent paint. The colors and patterns of underlying layers show through the transparent paper, instead of being covered. Dunning's delightful image is small, but eye-catching.

methods of handling. For example, Chromarama papers are stiff and require a heavier application of adhesive than other papers. Some rice papers, such as the lacy-patterned ones, necessitate applying medium to the support rather than directly to the paper, which becomes fragile when wet. Aesthetically, ready-made papers offer unique creative options. For example, thin papers, such as unryu, when adhered over strong colors, make lovely glazes that soften the color like a delicate, textured veil. Select lightly tinted or brightly colored paper as part of the color scheme for your collage. Experiment with different types of paper and keep notes on their behavior for future reference. In the projects that follow, you'll learn more about how to handle several kinds of ready-made papers.

Paper Terms

ACID-FREE Manufactured under neutral or alkaline conditions and internally buffered with substances that neutralize environmental pollutants and prevent deterioration.

DECKLE The natural edge of handmade or moldmade papers.

DETERIORATION The result of acidity, pollution, insects, strong light, dust.

GRAIN The alignment of paper fibers. Paper tears easily with the grain.

LIGHTFASTNESS Resistance to fading.

PH NEUTRAL The paper has been treated with an alkaline substance to control acidity. This prevents discoloration and deterioration. 7 pH is balanced (neutral).

RAG CONTENT The amount of linen or cotton fiber in a paper. High rag content usually means higher cellulose content and stronger paper.

SIZE OR SIZING A material mixed into the paper pulp or into which paper is dipped to make it less absorbent.

SURFACE Hot-press paper is smooth; cold-press paper is medium-rough (and is sometimes called "not"); rough paper is heavily textured.

URBAN RAIN FOREST #5 by Willis Bing Davis. Cut and torn paper collage, 30" × 22". Collection of Irene McGill-Bell.

Silkscreened colored papers lend themselves to strong designs emphasizing shape and color. The intense colors contrast sharply, while the white, torn edges add definition to the shapes. It takes practice to tear the larger shapes and adhere them without scratching the paper or smearing it with medium.

PROJECT FIFTEEN: **Rice Paper Collage**

Countless oriental rice and mulberry papers, including kinwashi, natsume, chiri, unryu, taiten and hosho, are available to the collage artist. They are sold in sheets and in pads used for oriental painting. Although art supply stores usually carry some of these papers, a greater selection can be found at mail order houses listed in the Appendix.

Oriental papers come in a variety of colors, weights and textures, lacy and glittering, with fibers, bark and other interesting materials embedded in them. These papers provide unique tactile sensations that enhance your enjoyment of the collage process. They can be tinted with watercolors, lightfast inks and acrylics before or after adhering, or used in their natural color.

Many oriental papers are somewhat transparent, so if you wish to retain the natural colors of the papers, use white illustration board, or prepare a white support by coating a board with white gesso. Dry the coated support thoroughly before arranging the collage.

Use matte medium to preserve the natural beauty of the papers. Brush the medium gently on the back of the piece to be adhered. Lift and place it carefully on the support. For large pieces, or if the paper seems fragile (some rice papers are extremely fragile when wet), brush medium directly on the support, lay the rice paper on the wet medium, and pat down or roll with a brayer.

Torn rice papers have wonderful edges, particularly if long fibers trail from them. Rice papers are difficult to tear when dry, so to control the direction and shape of

CLOUDS by Nita Leland and Virginia Lee Williams. 12" × 15".

Working with rice paper requires some experimentation to learn how to handle delicate papers when they are wet with medium. Brush medium on the back of the pieces, unless they seem too fragile when wet. In that case, brush medium directly on the support and apply the piece to the wet medium.

This detail of the finished collage shows how you can create lovely, textured areas in your rice paper collage. Shape wet papers as you adhere them or loosen the edges while the adhered paper is still wet and work them with your fingers to soften and roll them. The light causes shadows to play across the textured surface.

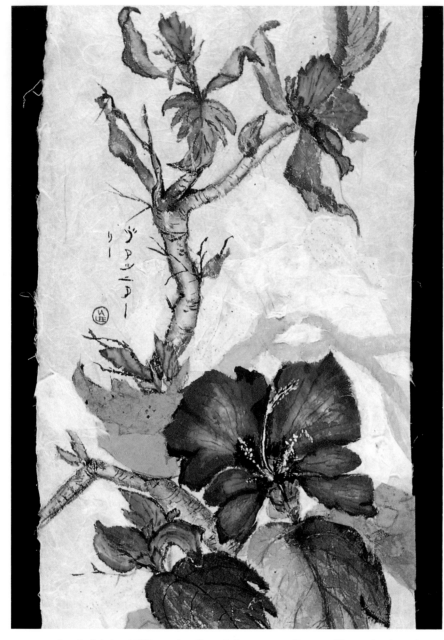

HIBISCUS by Virginia Lee Williams. Acrylic and rice paper collage on illustration board support, 24½″ × 12″. Collection of Hilda R. Dickenson.

Another use of rice paper collage is to add textural interest to a painting done on rice paper. In this collage, bits of natural rice paper were added to texture the background and colored rice paper was applied to the green leaves to create more depth.

a tear, use a clean, wet, pointed brush to moisten along the edge of the area to be torn. Pull apart carefully along the dampened line.

Choose three or four different types of rice paper in variations of a natural color, white or off-whites. The unity of color will create a harmonious picture. For this project work with shapes and textures only, without a subject. As you arrange the pieces, keep in mind the design elements and principles discussed in chapter five.

Starting with two or three large pieces, add contrasting pieces, overlapping their edges. Create a focal point and connections between areas. Trace lightly around pieces to mark their placement and lift off sections of the arrangement, from the top down, to adhere the pieces beneath. Be sure to bond small surface pieces to the larger sections before you move them. Your design may change slightly as you shift the pieces around. Also, note that some rice papers tend to stretch slightly when wet.

Observe how some layers are transparent and allow underlying textures to show through to different degrees, creating an interesting push/pull effect in the final design. The element of surprise is part of the fun—and challenge—of collage. If the result isn't what you planned, add another piece. Dry your collage with a hair dryer as you go along, because rice papers look darker when they are wet and this can be misleading. Adapt to changes as they occur, thinking about design, design, design!

PROJECT SIXTEEN: Creating a Torn Paper Organic Design

In this project you will create a torn paper collage that emphasizes the soft, organic shapes natural to torn edges. Select five or six colors of Color-Aid, Chromarama, colored charcoal or pastel papers. Handle the papers carefully, since some of the smoother surfaces scratch easily. Your support can be illustration board, canvas board or heavy watercolor paper. You may prefer to use illustration board since collage pieces that are wet with medium are easily moved around on this surface. If you plan to cover the entire support, you needn't use a white surface, since these papers are opaque. The matte surface quality of the papers makes it essential that you use matte medium to adhere them to your support so there will be no shiny spots on the collage.

You can begin with a general subject or you can work intuitively, playing with big shapes and letting a strong basic design evolve. Tear several random shapes from your colored papers. Some of the papers will reveal an interesting white or colored edge when torn.

Make this part of your design. Devise a center of interest or focal point. Remember the principle of unity and establish dominance of one color, a certain shape or a directional movement. Think of these design factors as you work out any collage.

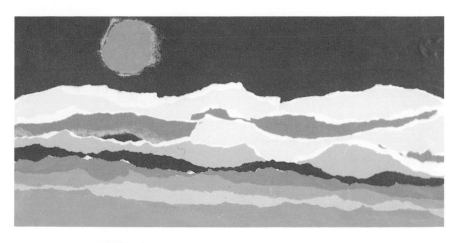

BLUE MOON by Nita Leland and Virginia Lee Williams. Torn paper collage with Chromarama paper, 7" × 14".

Torn paper makes effective landscapes, because of the organic nature of the soft, torn shapes. Keep design in mind as you arrange the colors and shapes and adhere them.

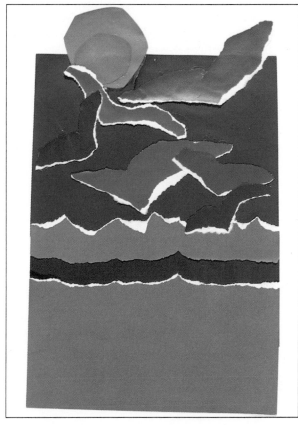

MOONSHADOWS by Nita Leland. Color Aid paper collage, 10½" × 8".

Letting collage shapes overlap the background or mat introduces an interesting design treatment, while cut edges add contrast against the torn shapes in this abstract collage.

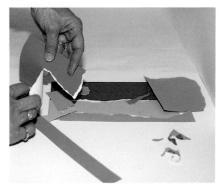

To create a white torn edge, tear your paper upward. Some papers produce a wider edge than others. With practice, you can learn to make this edge wide or narrow by changing the way you hold the paper and the direction you tear it.

PROJECT SEVENTEEN: Making a Collage Mosaic

Another collage variation is the mosaic, which uses small bits of paper to build up larger designs without overlapping pieces. Use any combination of colored art or magazine papers, selecting a unified color scheme. Adhere them in patterns, either an overall design or a realistic image. Unlike previous projects, do not lay the pieces out before you adhere them. Plan the overall design before you begin. Cut or tear small pieces of color, placing and adhering them as you go along. After you have applied several pieces to an area, wipe it gently with a damp cloth to remove excess medium.

Build up forms and patterns with small bits of color, leaving white spaces between pieces to create sparkle. This procedure gives a lighter look to the collage. As always, pay close attention to colors, values and textures. Keep the sizes of the pieces fairly consistent in each area, but use slightly larger pieces in some areas to create contrast.

(Left)
SOARING by Nita Leland and Virginia Lee Williams. 10″ × 7″.

This mosaic collage lets the white support show between the bits of paper to add sparkle.

(Below)
MAGIC QUILT by Virginia Lee Williams. Acrylics with paper and fabric collage, 10½″ × 10½″.

An assortment of ready-made and handmade papers are combined in a cut-paper mosaic. The cut squares are arranged in a checkerboard fashion, with careful attention to color and texture repeats.

In the mosaic collage process, tear and adhere small bits of colored papers and magazine colors on illustration board support without overlapping the edges, allowing the background to show through. Instead of arranging the entire piece before adhering, plan the general design, then tear and adhere each area as you go. Otherwise, if someone opens the window (or if you sneeze), the dozens of small paper pieces will fly away.

Designing Collage Abstractions

Many artists move freely between realism and abstraction, frequently combining them in the same collage. Try your hand at abstract collage. Keep in mind that all art requires solid design underlying the image. There are marvelous examples in this book, such as the realistic *Wall Street* on page 30 and the more abstract *American Machine* on page 37. *Co-alescence* on page 38 is a fine example of pure nonobjective design. The following section will help you gain a better understanding of abstraction and nonobjective design.

DESIGNING ABSTRACTIONS

Collage artists use design elements and principles to abstract, or reveal, the "essential" nature of real things: the wavy lines of a turbulent sea, the solid shape of a rock wall, the delicate lines of climbing ivy. By reducing the picture to just a few indications suggesting the subject, you needn't provide a detailed image. In fact, the image may disappear completely, leaving only the symbolic lines and shapes that represent its origin, as in the abstract *Urban Rain Forest* on page 48.

With nonobjective design, the picture has no apparent reference to a subject, like *Convergence* on page 54 and *Illinois Series: On the Road* on page 39. Instead, the formal elements of design are the picture. The picture is "about" color, line or shape without a specific realistic image to create the visual sensation.

As you design, look at your collage from different directions, upside down and sideways or hold it up to a mirror. Stand back and squint your eyes to discern areas that need correction. When the design is working, it looks balanced, even when it is upside down.

An abstract design may develop into an exciting, realistic image, or occasionally, what started as a realistic picture may become abstract, as you eliminate detail and simplify shapes. Working with de-

PARIS IN SHREDS by Phyllis Lloyd. Mixed media, corrugated cardboard and found papers (discarded opera billboards found in Paris), 30" × 40".

Abstract art is primarily about design. Because of the particular importance of shape, collage abstraction is highly effective. If it weren't for the type, this piece would be totally nonobjective. It works because of the powerful abstract design of bold color, strong shapes and interesting textures.

sign principles, you can go either way, creatively and confidently.

Work out different ways of designing abstractions in collage, keeping the emphasis on the formal elements of design, rather than a subject. Decide which elements and principles of design will be dominant. Let yourself work intuitively. If you get stuck, refer to the design list to break through the block. For example, suppose you want to make color the subject of your collage. Plan a color scheme you like and decide which color will be dominant. How will you arrange these colors? Will you emphasize organic or geometric shapes? Will you use any lines? What elements will you repeat and how will you vary them to create interest? As your plan evolves, subordinate these elements to color.

In the projects that follow, practice designing abstractions in collage.

BLACK RIDGE SNOW by Jacqueline Kuhl. Water media and wax crayon with charcoal paper, black sandpaper and cloth on illustration board, 16″×30″.

Good realistic artwork translates into solid abstract design; Kuhl's collage goes both ways. If you think of your design as simple collage shapes in the planning stage, any approach, whether realistic or abstract, will be much more effective in the long run.

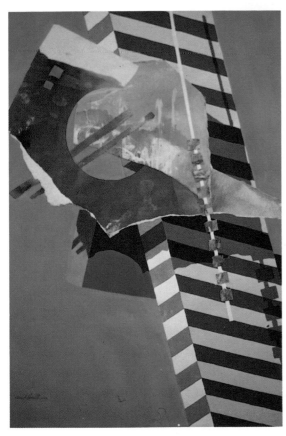

SPACE TIME LAPSE by Edwin H. Wordell. Gouache, watercolor and acrylic collage on rag paper, 30″×22″.

This nonobjective collage capitalizes on bold shapes, strong pattern and vibrant complementary color contrast to create an eerie sense of three-dimensional space.

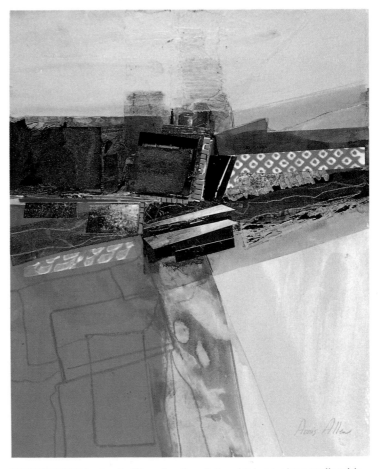

CONVERGENCE by Annis Allen. Acrylic paint and Prismacolor pencils with found papers, 19″×15″. Photograph by Jeff Rowe.

This well-designed abstraction has excellent balance from every viewpoint.

PROJECT EIGHTEEN: Geometric Abstraction With Cut Paper

For this geometric abstraction you will cut, rather than tear, paper, since a geometric design is stronger with hard edges. Cut several large, geometric shapes, based on the circle, triangle and rectangle, from one color of ready-made paper.

Now, plan a simple design. Is your picture about color, shape, movement or pattern? Do you want curved or straight edges? Will the composition be horizontal, vertical or diagonal? What other design elements do you want to incorporate? How will you use repetition of shapes and colors, rhythm and gradation? Which element will dominate? Base your nonobjective picture on the elements and principles of design.

Arrange your assorted shapes and sizes on illustration board or heavy paper that you have prepared with a coat of gloss medium. Adhere each piece with matte medium, let the collage dry, and seal it with a thin coat of medium or thinned gel and a coat of matte varnish.

You can also design geometric abstractions with found papers, although the printed lettering and patterns sometimes suggest images that interfere with the nonobjective emphasis. This is perfectly all right, as long as the fundamental abstract design is strong. Let yourself go wherever your collage takes you.

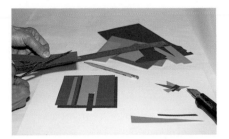

We selected violet as the dominant color for this geometric abstraction, and decided on a whim to use a blue-green accent; trust your intuition now and then. Large squares, cut hard-edged triangles, rectangles and other geometric shapes build up the nonobjective design.

PUSH/PULL by Nita Leland and Virginia Lee Williams, 10″ × 14½″.

Value contrasts create a sense of form and help move the viewer's eye around the picture. The hard, geometric shapes and strong color make a powerful combination.

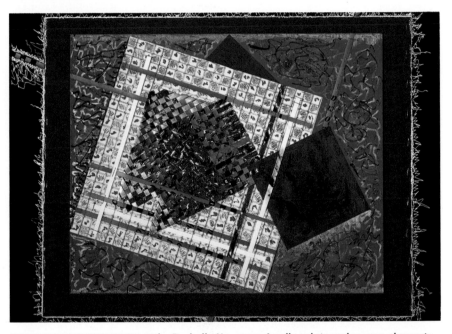

MAVERICK MOMENT SERIES #2 by Rochelle Newman. Acrylic paints and woven elements, 16″ × 23″.

The large squares that dominate this design are repeated in the small squares in the woven pattern, making this piece wonderfully consistent throughout. The analogous blues and greens dominate the color scheme and further unify the design. Then, the linear squiggles in the background cause the solid shapes to float, making this a very active piece. Simple shapes don't necessarily mean a simple design.

PROJECT NINETEEN: Organic Abstraction With Cut Paper

All of nature is designed around organic shapes, from spiral seashells to tree branches and rolling waves. As a collage artist you can play with these natural, organic shapes, rhythms and patterns to create exciting abstract designs. Select a dominant movement, horizontal, vertical or diagonal, and work with a variety of cut ready-made paper shapes, arranging and rearranging them on coated illustration board or heavy paper until you like the design. Then adhere these shapes to the support. Remember, a dynamic design doesn't have to be complicated.

As you play, you will probably discover that organic designs have a way of suggesting subjects in nature. Some artists like to play with organic cut paper collage designs until they find a design they like, at which point they make a natural subject fit the design shapes. You might like to try this approach. Begin with black, white and shades of gray, developing organic value sketches in collage.

Another way to work with nonobjective forms is to combine both geometric and organic forms with cut edges in the same collage. Make another nonobjective composition in this way, as well.

GREEN PEPPER by Nita Leland. Color Aid paper collage, 9" × 6".
Torn papers seem to lend themselves to organic abstraction, but you can also do this with cut paper. Collages can be made based on a design found in nature, like a spiral, branch or wave. This collage is based on the cross section of a green pepper.

FLOATING WORLD by Arthur Secunda. Handmade paper collage, 28½" × 22".
This abstraction strongly suggests natural forms. It might be a geode or the cross section of a piece of agate. It could refer to a magnification of a cell or the rings around the heart of a tree. Whatever the subject may be, the abstract design is solid with the unifying element of analogous colors and organic shapes; this visual strength is the object of design.

PROJECT TWENTY: Combining Cut and Torn Papers

This project encourages experimentation with both cut and torn edges. Play with combinations of different colored papers and oriental papers. Do you want to feature texture? Color? Shape? Determine at the outset whether you want a hard-edged, geometric look with some soft contrasts or a flowing, organic composition with a few sharp accents. It's all up to you. Bright, solid-colored papers provide a different feeling from fibrous, translucent oriental papers.

Use any support. To adhere very small pieces of thin papers, use just a dot of medium. If the adhesive shows through where you don't want it to, add a tiny spot of rice paper on top of the bonded spot. Remember to follow the recommended procedures for collage. Here's a review.

1. Coat the paper or board on both sides with undiluted gloss medium or gel thinned 50/50 with water. Let it dry. Apply a coat of matte medium.
2. Plan your design, whether realistic or abstract, making the most of color.
3. Arrange your collage pieces and adhere them with matte medium. Wipe off excess medium as you go. Dry.
4. Coat with a thin coat of gloss medium or gel. Add a final coat of matte satin varnish for a low-gloss finish.
5. Dust lightly with cornstarch prior to storage.

SUMMER LIGHTNING by Nita Leland and Virginia Lee Williams. Ready-made paper collage, 10″ × 15″.

Abstraction defines an "essence," or essential nature of a subject. Here, by combining cut and torn paper in the collage, and by simplifying shapes and taking liberties with nature, we have created an abstract design that is strongly rooted in realism.

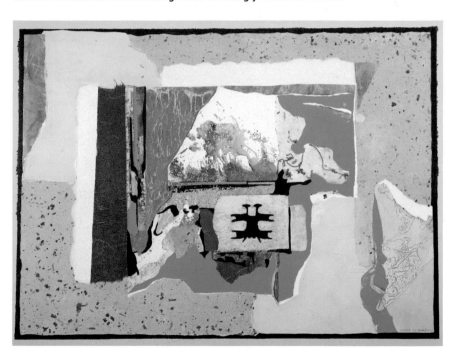

SHAMAN'S JOURNEY by Valaida D'Alessio. Rice paper, torn watercolor paintings and cut-out figure, 36″ × 48″.

This arrangement of a variety of ready-made and hand-painted papers employs both torn and cut edges. As you add new techniques and materials to your bag of tricks, try them together and see what effects you get. What happens if you make your realistic works more abstract, or add some realism to your abstract composition?

DEMONSTRATION TWO: Designing With Ready-Made Papers

Many fine collages simply "evolve" from start to finish. However, in this demonstration we want to show you how to plan a striking collage design and carry it through to completion. If you have never worked this way before, you will discover that thinking through the whole process will help you to better understand design. You'll be glad you did, and your work will be stronger for it.

STEP ONE. An orchid, larger than life, seemed like a fun idea for this demonstration. First, we researched our subject, so we could make a believable flower in a simplified design form. Then, we tried out several different arrangements in preliminary value sketches. The dominant elements would be shape and color, with contrast and repetition of elements controlling the design.

STEP TWO. Colors found in nature are a safe bet, so we used violets and greens for the color scheme. We laid out an array of colored papers and picked those that gave us the color and value contrasts we wanted, with the violet leaning toward red and the greens an assortment of analogous hues. We chose a sharp accent of a red-orange that was complementary to the blue-greens in the background.

STEP THREE. To enlarge our drawing, we made a grid on our value sketch and a similar grid on tracing paper the same size as our prepared collage board, then copied the drawing into corresponding squares on the larger grid. We rubbed the back of the tracing paper with a 2B graphite pencil and wiped the paper with rubbing alcohol on a cotton ball to keep the graphite from smudging the prepared board. Then we laid the paper with the graphite side down and transferred the drawing to the board by tracing over the lines on the tracing paper.

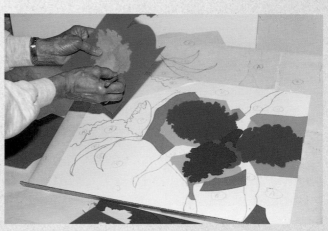

STEP FOUR. We number- and letter-coded the shapes on the tracing paper pattern to correspond with numbers and letters on the support. Then, we cut up the pattern and traced the outlines on the colored papers, writing the numbers and letters lightly on the backs of the pieces. Background pieces were cut a bit larger, so they would fit under the intricate edges of the flower petals.

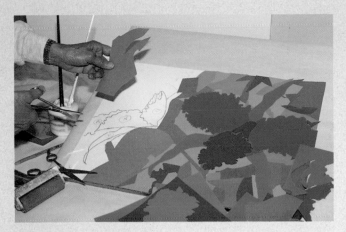

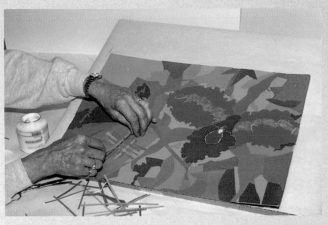

STEP FIVE. We worked our way across the support, tracing, cutting and adhering shapes to the drawing as we went along. The big background shapes were broken up into different values and colors to suggest the flickering light of the rain forest surrounding the orchid. These contrasting pieces were carefully selected to emphasize the petals of the large flower. Occasionally, we stepped back to study the overall effect.

STEP SIX. Some final touches were added to complete the piece. Narrow strips of fibrous rice paper gave form to the petals. The red-orange focal point was placed on the dark throat of the larger orchid. And a tiny woven paper piece was attached to the background for a decorative touch, suggesting a grassy texture and bringing an element of surprise into the picture. The entire piece was encased in one coat of gloss medium and a final coat of matte medium.

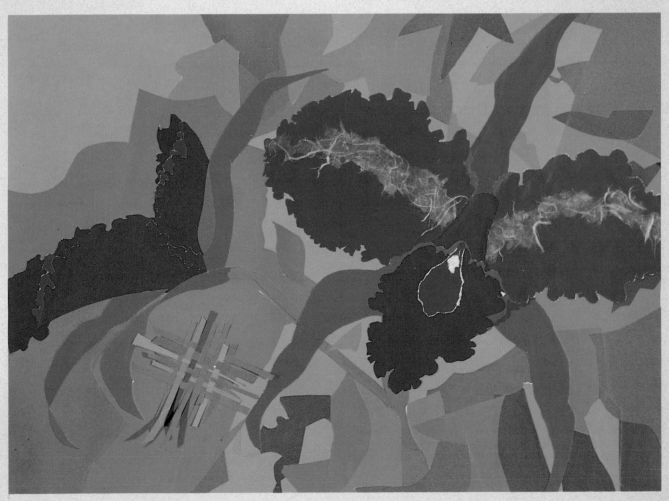

TROPICAL SPLENDOR by Nita Leland and Virginia Lee Williams. Paper collage on illustration board, 15" × 20".

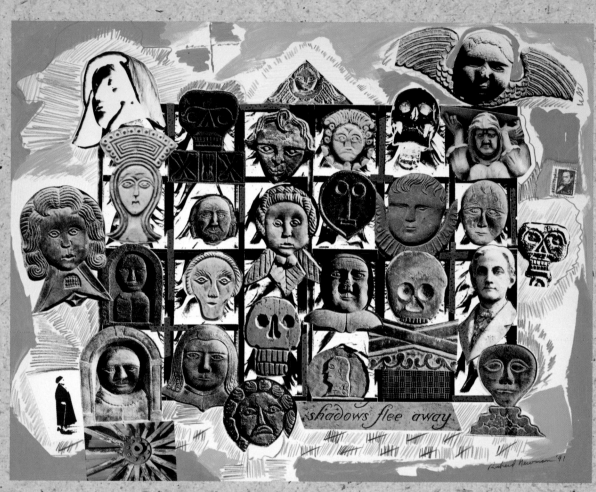

SHADOWS FLEE AWAY by Richard Newman. Acrylic paint, colored pencils and photographs, 16″ × 20″.

Combine paper collage with a variety of other mediums to expand your capabilities of creative expression.

CHAPTER EIGHT
More Techniques and Materials

T hus far you've used the tradi-
tional methods of paper col-
lage — cutting or tearing papers
and adhering them to a support.
These techniques are pretty
straightforward — using acrylic me-
diums to fasten materials to a
coated, rigid support, such as
heavy paper, illustration board or
canvas board, sometimes toned
with watercolor or acrylic washes.
This chapter encourages you to ex-
plore further, using non-paper
mediums to enhance color and
texture or to unify design elements
in your paper collages and incor-
porating photographs in your col-
lages.

COMPATIBLE MEDIUMS

Most art mediums are compatible
with paper collage: watercolor,
gouache, casein, inks, acrylics,
pastels, charcoal, oil pastel or
crayon. Your favorite medium will
probably work with collage, but

CLIFF DWELLERS #1 by Katherine Chang Liu.
Mixed media collage, 44″ × 31″. Courtesy of
Louis Newman Galleries, Los Angeles. Pri-
vate collection.

Mixed media collage may include paint, ei-
ther watercolor or acrylics, with collage ap-
plied on it; pre-painted papers torn and
used as collage; and pencils, pastels and
other art media. Good design is always the
foundation that unifies the diverse compo-
nents of mixed media.

you should try everything. As you use mixed media, you'll soon discover which you prefer.

Starting with the simple projects described here, devise combinations that create a distinctive look to your work. The effects you get will depend on which materials you're using in the collage. For example, shiny magazine papers, photographs or silkscreened papers may resist watercolor or pastel lines. Be aware that acrylics do not adhere properly to any surface that contains oil, but mediums such as oil pastel, crayon and wax-based colored pencils can be applied on top of an acrylic base.

(Above)
SPIRIT VIGIL by Cynthia Ploski. Watercolor with laminated rice paper and found objects, 29" × 37".

It isn't necessary to laminate an entire surface with rice paper to get a good effect. Watercolor plays very nicely against the textured paper portion of this piece, giving depth and dimension to the image.

(Left)
MADRIGAL REGALIA by Marta Light. Ink, watercolor pencil and collage, 40" × 30".

Lovely collages can be created with watercolor and mixed media. The elegant, courtly figures are arranged on a contemporary abstract background, creating ambiguous time and space.

PROJECT TWENTY-ONE: Paper Collage With Colored Pencil

In this project you will add drawn lines to a simple paper collage. Test your materials to make certain they will show up on the colors and surfaces you're using. Try wax-based colored pencils, oil pastel, pastel, crayon, charcoal, soft graphite pencil or waterproof India ink. Use opaque colors to make certain they show up, selecting colors that harmonize with your collage.

Once your tests determine which materials will work for you, design and make a collage using large shapes and solid colors. Work with a theme, subject or a geometric abstraction to unify the basic design. Use coated illustration board or mat board as your support and adhere pieces with matte medium. Let your collage dry thoroughly before coating it with gloss medium and one coat of matte varnish.

Now the fun begins. Draw on the surface, adding lines, textures or figures to your collage. Enhance textures with a pattern of cross-hatching (evenly spaced, overlapping lines) or stippling (fine dots of paint); connect shapes with colored lines; and reinforce your abstract design or emphasize your concept with images that support the theme. But don't overdo it. Use restraint, so the design doesn't get too busy. Occasionally add a few gestural scribbles to contribute a sense of energy to a piece.

OH SACRED SOLITUDE by Virginia Lee Williams. Acrylic paints, graphite pencil on rice paper and brayered paper collage, 30" × 22".

A network of graphite lines crawling across the collaged and painted surface ties different elements together into a cohesive design. The lines define and repeat the jagged edges of the torn papers and have a dynamic energy of their own.

Test an assortment of colored pencils on scraps of Color Aid or Chromarama paper. Some will be much easier to see on the surface of the colored paper. Then make a collage using big geometric shapes and contrasting colors.

PICTOGRAPHS by Nita Leland and Virginia Lee Williams. Paper collage with Prismacolor pencil on Illustration board. 10" × 12".

Draw or scribble lines on your collage, creating connections between the pieces to move the viewer's eye around the picture.

PROJECT TWENTY-TWO: **Autobiographical Collage**

Your goal in this project is to design an autobiographical collage: the story of your life or a day in your life in pictures, incorporating journal entries, photographs and personal mementos. You can even write autobiographical statements on the surface in crayon or pencil. Look at all the sources you have to choose from: newspapers, magazines, photographs, colored papers, rice papers, drawing tools and paints.

Combine methods and materials in creative ways for a unique artwork. Show your individuality in this collage. Your self-portrait collage may be a likeness of you, or it may describe you abstractly through your choices of personal themes and design symbols.

Determine a focal point and plan distinctive color. Organize, but as you put it all together, relax and have fun with it. Be open to change as you add new pieces or take others away to reshape the design. Draw and paint images in the background. Add lines and colors with water media or drawing tools.

Stand back from time to time to view the overall picture. Squint your eyes to check the values, colors, design movement and center of interest. Use the basic methods for adhering materials and protecting the finished piece.

Start a collection of autobiographical materials — pictures of things you love and symbols that mean something to you. Include some things you dislike, as well, as these can sometimes trigger a powerful response that comes through in your art.

FACETS by Elaine Szelestey. Cut paper collage, 14" × 19½".

Szelestey is a skilled figure and portrait artist in watercolor. In this radical departure from her usual medium and techniques, she used found papers and snippets of photographs to assemble a two-dimensional self-portrait. Acrylic matte medium is the adhesive.

PROJECT TWENTY-THREE: Using Photographs in Collage

Photo collages are to artists what autobiographies are to writers—a trip down memory lane or a peek at the unconscious. Design a photo collage, using photographs as part of a paper collage or assembling an assortment of photos in a photomontage.

Start with current candid photos in black and white or color. For consistency, use one or the other, not both, in your collage. Select your photos around an event or a theme and choose photos that are in good condition with clear, clean images.

Handle all photos with clean, dry hands, wiping fingerprints off the photos with a soft, dry cloth. Spray the front of the photos with Krylon matte spray to create a non-glare surface and to protect the emulsion from damage. (Be sure to spray in a well-ventilated area, following the directions on the can.) Let the photo dry a minute or two before handling it.

Plan your collage on illustration board, arranging the photos around a focal point, repeating colors to draw the viewer's eye around the collage and emphasizing value contrasts at the focal point. Trim some photos into silhouettes to make interesting shapes. Overlap some edges. Draw lightly around the edges of the shapes to mark their placement on the support. You can embellish the design later by adding line or color in the background spaces between the photos.

Use matte gel medium to adhere the photographs. Since photographic paper is stiff, it needs to be adhered with matte gel, which is extra strong, thick and less likely to run onto the photographs and

CONNECTIONS by Nita Leland and Virginia Lee Williams. Photo collage, 14" × 14".

Photomontage—mounting a collection of photos together—has been popular since the beginning of photography. Unify a composition by sticking to a theme or subject and using only black-and-white photos or colored snapshots in the collage. This photo collage was arranged with open spaces between the untrimmed pictures, then graphite lines were drawn to connect the adhered images.

BEACH PARTY by Nita Leland and Virginia Lee WIlliams. Photo collage, 13" × 18".

These photos were trimmed to create interesting shapes and edges. Use matte gel medium as the adhesive for stiff photographic papers.

streak the emulsion. Using a stiff brush, spread the gel generously on the back of the photo just short of the edge, then thin it out to the edge. Place it on the support and pat it down. Keep medium and water off the surface of the photos. If you haven't sprayed your photos with Krylon, don't use a wet brush or wipe them with a damp cloth.

You'll see that your photographs will tend to curl after the medium is applied. Affix one or two photos to the support, then place the waxy side of freezer paper face down on them and weight with a book or board till they dry. Repeat the process for the remaining photos. Add line or color with pencil, watercolor wash, acrylic, pastel or paper collage to finish.

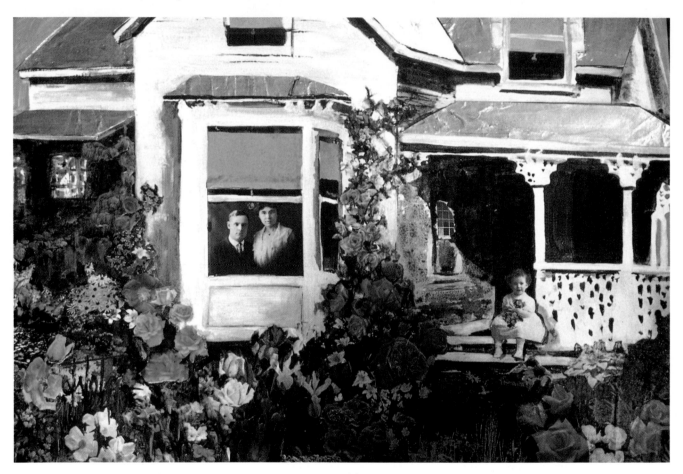

LOOKING THROUGH ROSE-COLORED GLASS by Jeanette Wolff. Mixed media with acrylics, inks, photographs and found papers, 20" x 30".

This is a fine example of mixed media collage with photographs. Wolff has painted the house with acrylics, collaged photographs and cut papers onto it, and finished up with ink and paint glazes. The different elements are beautifully integrated.

PROJECT TWENTY-FOUR: Using Antique Photos

A carefully assembled group of antique photos is an invaluable memento that speaks of times past. Your own wonderful old family pictures are probably languishing in a box high on a closet shelf. Dust off the box and see what you find inside that you can put into a photo collage. Your collage may be a commentary on your family heritage or a statement about the Good Old Days. Start with a water media background or connect images with painted lines and colors.

Working with antique photos requires special care. Be particularly careful with irreplaceable photos. You may prefer to have copies of your antique photos made at a custom photo finishing lab. To protect photographs, spray them with Krylon matte spray in a well-ventilated area. Since old photos were often mounted on heavy cardboard, securing these photos to illustration board is a step-by-step process. Make a small practice collage from an old photograph to test the amount of matte gel medium needed to adhere the photo. Cover the adhered photo with the waxy side of freezer paper and weight it down two or more hours until dry.

When you are ready to secure the photos, adhere the bottom pieces first and weight them down until dry. Build the collage layer by layer, letting each layer dry before adding another. Be careful not to smear the image. If you must clean medium off the photo, use a barely damp cloth and wipe gently.

Finish by painting and decorating with other media. Add watercolor or acrylic washes of burnt umber or burnt sienna to blend with the antique patina of the old photographs or draw Victorian gingerbread on the background with colored pencils or pastel.

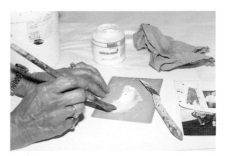

(Above)
Photographs, particularly antique photos mounted on cardboard, require a heavier medium than many papers. Apply matte gel medium generously to the back. Spread the medium toward the edges, thinning carefully, so it won't squeeze out when you adhere the photo. Place freezer paper on the mounted photo and weight it until dry before adding more photos or collage materials.

(Left)
AULD LANG SYNE by Nita Leland and Virginia Lee Williams. Photo collage, 18" × 16".

The rigid alignment of these old family photos emphasizes the character of the times, in contrast to the clowning around in some of the pictures. Contrasts like this make collage photo arrangements more interesting and fun to do. The background wash gives an antique look to the whole piece.

RUST IN PEACE by Peter Tytla. Photo collage, 40" × 30".

Tytla began with a 20" × 30" enlargement of one of his own photographs for the sky and background. Then he added cutouts from as many as two hundred photos of old cars, people and places he has taken around the country. The process may take up to five weeks, but the fun he has taking his photographs and his sense of humor are evident in every piece.

Watercolors With Collage

Watercolor and collage are highly compatible, with a relationship that ranges from painting the support to overpainting the collage. You can start out with bold, splashy washes as a background and build up a collage design or image superimposed on that. You might strengthen values in a watercolor with dark bits of collage or add rice paper texture to the surface, painting back into it with watercolor. Just remember, either the collage or the watercolor technique should be dominant, but not overpowering.

Don't ever throw your old artwork away. You can recycle your old paintings. Use collage to enhance those drawings and watercolors that need some sparkle. Add watercolor washes to unify areas in an unfinished collage. Be bold. Make a commitment. This is a challenging and exciting new dimension in your art.

Papers and acrylic mediums behave differently with watercolor. Some absorb and others repel the color. Test your papers with watercolor and experiment with watercolor mediums, such as ox gall to improve the flow of the paint or Aquapasto to give it a heavier body or shine. You can paint over your mistakes with opaque acrylic

gesso, then use Golden's Absorbent Ground to coat the surface so it will accept watercolor without crawling.

Several mediums qualify as watercolor: transparent watercolor (in tubes or liquid form), gouache, casein, and even acrylics thinned with water and medium to watercolor consistency. The term "water media" has come into common use and is used in this book to include these and other water-based mediums applied in an aqueous manner, as washes rather than as a thick paint film. When working in pure, transparent watercolor, coat only the back of the paper or board with gloss medium if you wish to retain the handling characteristics of watercolor on the surface.

MONUMENT VALLEY by Harold E. Larsen. Watercolor, watercolor pencil and acrylics with rice paper and handmade papers, 30" x 40".

Larsen has achieved a beautiful transparency with water media and stained rice papers. Traditional watercolor and acrylic watercolor can easily be used together in the same painting. The watercolor pencil, which is fully compatible, adds a nice touch here.

PROJECT TWENTY-FIVE: Watercolor With Collage

Gather together an assortment of collage materials, such as scraps of rice paper, newspaper or magazine clippings, along with gloss and matte medium and your palette of watercolor paints. Begin with watercolor washes over a light pencil sketch of your subject or flow paint boldly on the surface and draw into this background after it dries. As you paint the shapes, watch for areas where collage materials might create interest: rice paper textures on rocks or newsprint on the side of a building or fence.

Encase the collage pieces (except for rice paper or watercolor paper) with gloss medium as described in the "Encasing" project on page 27. Adhere them to the watercolor, then brush a coat of matte medium over the collage pieces, being careful not to brush medium on the watercolor. Dry with a hair dryer, then paint back into the collage pieces with watercolor, so they blend into the picture. Continue painting and adding collage, carefully evaluating the result each time you adhere a new piece. Don't overdo it. Let the watercolor technique dominate this one.

Matte medium works better than gloss medium as an adhesive with watercolor, because it doesn't create shiny spots on the matte surface of a drawing or watercolor. Newsprint, tinted with light washes of burnt umber or yellow ochre watercolor, is ideal to represent worn textures or to suggest old surfaces. Adhere newsprint with medium and sponge gently while still damp to smear the words. Handle the collage pieces carefully, so you don't drip medium on the artwork. Remember, don't brush the surface with medium or you may disturb the watercolor or drawing.

For this collage watercolor washes were applied freely on an abstract design shape; additional spraying moved the paint around. The watercolor was dried thoroughly before beginning the collage treatment.

The eagle was lightly sketched on the design shape before collage was introduced in a few key areas. Fibrous rice paper added a textured look to the feathers on the head and tail of the eagle, and an ad for a woven shoe provided additional interest in the focal point.

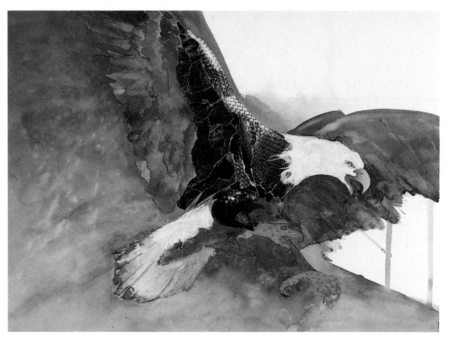

DESCENDING EAGLE III by Nita Leland. Watercolor collage on illustration board, 15" × 20". When the collage bits were dry, light values were sponged out, carefully avoiding the collage areas; watercolor washes enhanced contrasts and colors. Details and glazes sharpened the image.

BUDDIES by Pat Clark. Mixed media collage, 18″×14″.

Spontaneous washes create a watery background for the fish cutouts. A peacock feather provides an interesting accent, picking up the rhythms of the underwater plant forms. Notice, too, how Clark has picked up those rhythms in the patterns on the fish and repeated the colors of the fish in the background. Good design thinking.

PROJECT TWENTY-SIX: **Watercolor on Rice Paper Collage**

Watercolors look quite different when applied to a collaged support. The paper absorbs the paint unevenly and the results are subtle variations in hue and value that are beautiful to look at — and challenging to work with. The paint crawls through the fibers and settles into wrinkles in the paper, making the surface look like batik. The paint has a mind of its own, so don't try to control it. Go with the flow.

For this project use thin, transparent layers of rice paper or Niji craft tissue and watercolors.

To laminate an unpainted support with a layer of rice paper, brush the coated support with matte medium and lay a sheet of rice paper on top of it. Use a brayer to roll the surface flat, but allow the paper to wrinkle for interesting textures. Puncture bubbles with a pin and roll the surface again to remove air. Most rice papers require careful handling, but some heavier-weight papers may be brushed with medium and then placed on the support. If the paper tears as you handle it, simply patch it with a small piece of rice paper and matte medium. You can also build up a heavily textured surface by tearing the rice paper into pieces and adhering them in layers across the support.

Paint on the bonded rice paper as you would any watercolor paper. Make creative adjustments to the unusual effects of watercolor washes on an acrylic surface; for example, where the paint soaks into the crevices in the wrinkled paper, create a textured area. If necessary, put three or four drops of ox gall in your water to improve the flow of the paint.

Two different types of rice paper were laminated to the left and center of illustration board. The right side was left uncoated. Watercolor washes across the surface look quite different in each section, with paint soaking in and fading in the first panel, crawling and remaining fairly intense in the second and having hard edges and richness in the third.

MORNING LIGHT by Nita Leland, 15″ × 20″.

Wrinkled rice paper was the trick to creating the tree forms in this collage. Rice paper with heavy fibers running through it was laminated to coated illustration board. Wrinkling was encouraged. After the wet paper was brayered, a coat of matte medium was brushed over it. When the surface was dry, the watercolor washes were applied to the background and tree forms magically appeared in the wrinkles of the laminated surface.

SPIRIT DANCE IV by Marilyn Stocker. Mixed media collage, 17" × 21½".

The artist layered rice paper, tracing paper, gold papers, plastics and other materials on a laminated tissue support. She painted with acrylics and added collaged figures. The artist sees this layering process as symbolic of the multidimensional "spirit world."

MAIN STREET BRIDGE, DAYTON by David L. Smith. Water media, laminated rice paper on illustration board, 14" × 20".

In this landscape collage, Smith made a monochromatic underpainting on illustration board, then bonded fibrous rice paper to the entire surface to add sparkle. He completed the painting with transparent watercolor glazes. The rice paper fibers add sparkle to the landscape.

PROJECT TWENTY-SEVEN: **Rice Paper Overlay**

Rice paper overlay (laminating a watercolor with rice paper) gives you a second chance with watercolors, freshening up muddy, overworked areas or modifying garish color. The hazy overlay of semitransparent rice paper is sometimes called a "glaze."

First, coat the back of the watercolor paper with a thin coat of gloss medium to keep the paper from curling after the rice paper is applied. Dry it with a hair dryer. With a big brush, spread a heavy coat of matte medium quickly over the entire surface of the watercolor. Immediately lay a sheet of thin, textured rice paper, such as light kinwashi, over the wet surface, and pat the paper down or roll it flat with a brayer. Prick any air bubbles with a pin, pat them lightly, and let the paper dry. Don't worry about wrinkles. They add interesting texture.

Complete the picture with water media. Stop frequently to let the paint dry, so you can evaluate what's happening in the picture. (The rice paper layer will absorb the colors, so they look quite different when they are dry.) Repeat the rice paper application in small areas, to build up textures or modify values and colors, and repaint where needed to enhance colors and strengthen values.

You can combine several rice paper techniques in the same painting. For example, paint bold colors on a laminated rice paper support from Project 26, then use rice paper as a glaze over the painting to modify colors and to create textured areas.

The problem with this unfinished watercolor is that the preliminary washes were a bit too bright, and the whites had disappeared.

Matte medium was brushed onto a sheet of unryu rice paper, which was then adhered to the entire surface of the watercolor to tone down the color. A brayer was rolled over the surface to bond the overlay to the watercolor.

THE LIGHT BEYOND by Nita Leland. Watercolor and rice paper collage, 15" × 20".

Whites were built up with layers of rice paper. Then washes were enhanced and rock and tree forms brought out with watercolor.

Acrylic Paints With Collage

The versatility of acrylic paints makes them an excellent medium to use in your collages. They are quick-drying, flexible, durable, highly saturated in color and very forgiving—as with most opaque mediums, you can hide your mistakes! Acrylics will bond to most surfaces and once dry, cannot be removed. Acrylics will not bond to a surface with an oil content, however. Matte or gloss medium extends or thins these paints without weakening color and sometimes improves paint transparency.

You can buy acrylic paints in a wide selection of hues, including iridescent and metallic-effect colors. Suitable brands include Liquitex Acrylics (squeezable colors in tubes or creamy paints in jars), Golden Fluid Acrylics (in squirt bottles) or High Load Acrylics (in jars), and Rotring ArtistColor or Dr. Ph. Martin's Spectralite. These latter two brands are concentrated acrylics and are suitable for airbrush. Start with a few colors of each brand listed above so you can see which consistency you prefer.

You can apply undiluted, thick acrylic paints like oil paints to create rich textures and opaque layers, without the cracking associated with impasto painting. Or you can thin them as necessary with water or matte medium, or use the thinner liquid acrylics for a more watercolor-like effect and for tinting medium-weight rice paper for color glazes on your collages. Add water cautiously, though; too much water creates a weak paint that may not bond properly to the support.

A freezer paper palette will keep your acrylics moist. Wrap a length of the paper around a piece of cardboard or Plexiglas (10" × 12" or larger), securing it on the back with masking tape. To keep the paint moist as you work, mist it occasionally with water. To store the paint temporarily, spray it and cover with plastic wrap. When you have finished for the day, don't throw the paints away. Pour liquid acrylics into jars, add a little water, rub Vaseline around the outside of jar openings (to keep lids from sticking) and seal

HEWN OUT OF CHAOS by Virginia Lee Williams. Acrylics and paper collage, 21" × 27".

Textures are easily imprinted on heavy watercolor paper and used as a background for collage. Acrylic paints work best for this technique because the colors retain their brilliance when dry, and the dry paint is flexible and won't chip off where it is applied heavily.

tightly. Use these later as washes. Another option is to brush or roll leftover paint onto pieces of watercolor or rice paper, which you can file and use in a future collage.

Keep track of the new techniques you try as you work through this book. Paint samples of textured acrylic mediums and color mixtures (combined with paper collage materials, as well) on scraps of illustration board or mat board. Record the methods and materials you use on the back. Keep a detailed journal to note your results with some of the more complicated procedures in the chapters that follow.

There are virtually no limits to what you can do in collage using acrylics on paper or canvas. Every experiment leads you to new discoveries. Just keep in mind this basic point: Oil and acrylics don't mix. You can use oil paint or oil pastel on an acrylic base, but you can't use oils underneath acrylics or the paint will peel off.

Also, use matte mediums for most applications (first coating the support with gloss medium or gel) to cut down on glare and to prevent shiny spots where you adhere objects to a surface. Heavier mediums work best for heavy papers and objects. Clean excess medium from around the edges of adhered pieces before it dries. Any acrylic medium—including paint—can be used to adhere papers or objects, so you can quickly incorporate collage into an acrylic painting as long as the paint is still wet. Don't forget to encase the acrylic or paper collage with gloss medium or thinned gel to protect the collaged bits. Add a finish coat of matte varnish to reduce shine. (The exception is watercolor, which may be disturbed by coating. Frame these under glass.)

From start to finish, from sim-

ple to complex, procedures for all collages seem to be the same, don't they? Coat the support with gloss medium on both sides, adhere the collage material with matte medium, and coat the finished collage with gloss medium and a top coat of matte medium. All in all, it's a quite simple process.

FAMILY SERIES #3 by Mary Langston. Acrylic collage with beads, fabric, foil and found objects, 52″ x 32″. Represented by Eleanor Jeck Galleries, Tuscon, Arizona.

Most acrylic paints have more body and flexibility than watercolor, wet or dry, and as an added benefit, acrylics act as an adhesive when collage materials are applied to the wet paint. In this artwork, an acrylic painting on handmade paper is beautifully enhanced with collage materials.

PROJECT TWENTY-EIGHT: Acrylic Appliqué

Acrylics (tube, jar or liquid) dry as a plastic film or appliqué that makes a fascinating collage material. You can use an acrylic appliqué as the focal point in a collage or, if it is large, as background for other collage materials, which you would attach to the appliqué using matte medium or gel. You can also cut the film into smaller pieces and arrange them on a support as you would collage papers, or make several appliqués in different sizes, repeating the colors and shapes with variations, and then design a collage around them.

To begin, drip or pour a layer of acrylic paint on waxy freezer paper, making an interesting color design about six inches around. The appliqué may take several days to dry, depending on how thick the layer of paint is. When the paint is dry, slip a palette knife under the edges to work it free and carefully peel the color off the freezer paper to use in a collage. If the paint is thin, it will tear in places, making a more interesting piece. Bond the appliqué to a support by brushing a layer of medium on the support and patting the piece in place.

Before cleaning up, take a look at your palette. Have you ever noticed the beautiful paint mixtures you get on your palette sometimes? If the mixture is on a freezer paper palette, use a utility knife to cut the paper around it and set it aside on a flat surface to dry. Then, use this plastic film as acrylic appliqué.

Pour or spread acrylic paint onto plastic-coated freezer paper, using several colors in a free-form shape.

When it is completely dry, peel the flexible acrylic paint film off the freezer paper and use it in collage.

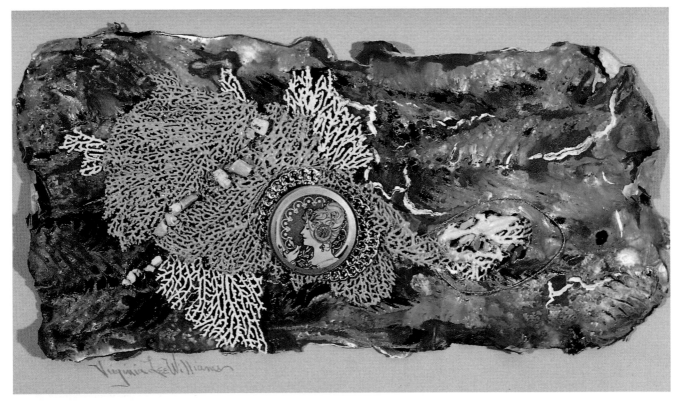

MARGARET ROSE by Virginia Lee Williams. Acrylic paint and found objects, 9" × 15".
A piece of sea fan and other found objects were embedded in a wet paint film. The entire piece was removed from the freezer paper and bonded to acid-free mat board.

PROJECT TWENTY-NINE: Textural Effects in Acrylic

Items such as shells, doilies, burlap and bubblewrap produce interesting patterns and textures when imprinted on collage papers with acrylics or with liquid watercolor, lightfast inks or gouache. In this project you will create a large sheet of imprinted paper which you can tear up and use as collage texture. Since you're not making a painting, you don't need to plan a composition for the imprinting.

Any sturdy watercolor paper will do, for example, 140 lb. cold-press Arches, Lanaquarelle, Winsor & Newton or Morilla watercolor paper. To minimize buckling or curling, stretch the paper by soaking it for thirty minutes and placing it on a ⅜-inch plywood board or on Gatorboard that is at least one inch larger all around than the paper. Staple the paper at 3-inch intervals about ½-inch in from the edge. Let the paper dry. To remove the paper after the imprinting is dry, slip the point of a knife under the staples, between the dry paper and the board, and pry the staples free.

Gather all materials before you begin. You won't have time to hunt objects after you have poured on the paint. Use several of these items: bubblewrap, burlap, gauze, doilies, leaves, shells, mesh bags, needlepoint canvas, patterned objects, plastic wrap, stencils and textured wallpaper. (See the Appendix for more ideas.) Coat both sides of items such as lace or paper doilies, stencils and leaves with two coats of medium to make them easier to handle. Wipe them clean and use them again and again; dust lightly with cornstarch so they don't stick together when stored.

Select several colors that will create an exciting color scheme. Prepare your paints by thinning them to the consistency of coffee cream, so they pour easily. If your paint seems too thin, add a small amount of matte medium to give it more body. Store leftovers in small jars with lids.

Spray the paper lightly with water and pour the paint slowly, allowing the colors to run freely, but not out of control. Brush into the paint, spatter or spray lightly with water to keep the color moving. Blot with a paper towel or damp brush if it becomes too soupy.

Place objects randomly on the wet paint to imprint their patterns and textures. Leave them in place until the paint is partially dry. This may take a while, depending on how wet the paper is. Lift up the edge of each object occasionally to see if the pattern is printing. Don't let the paint dry completely, or the objects may adhere permanently to the paper. You may repeat the

Imprinting in acrylics is a simple three-step process. First, pour two or three colors on stretched, wet watercolor paper and brush or spray with water to mingle the colors.

Cover the entire sheet with rich, wet acrylic color.

Place an assortment of patterned materials on the wet paint and leave them in place until the pattern has printed. Don't let the paint dry, or the pieces may be permanently adhered to the paper.

pouring process and overprint with color or white acrylic paint when the paper is dry.

Use spatter and stencil to create other textures. Cut stencils or lay objects such as leaves, keys or doilies on the surface of an imprinted sheet or a collage you're working on. Paint into the stencil or spatter liquid color (not too thin) over the stencil or object with a denture brush. Move the stencil several times to repeat the shape. Use different sizes for variety. Remove these objects and stencils or adhere some of them to your collage to create a positive/negative image contrast.

There are many ways to use imprinted and stenciled papers. Look for mini-compositions in the patterns and textures and use these as a unifying design element or a focal point in collage. Tear the patterned paper into collage pieces. You can also print the textures directly onto a watercolor board, illustration board or canvas support for use as the background for other collage materials.

ATLANTIS by Virginia Lee Williams. Acrylic and paper collage, 17″ × 19″. Collection of Dr. Michael W. Aveyard.

Papers may be printed in a random fashion, then used to make a collage. Cut them up and combine them with other textured papers to provide interest in a collage design.

PROJECT THIRTY: **Creating a Monotype**

Monotype is a simple way of creating a unique image, focal point or background for collage. You can use the monotype whole or torn up. To create a monotype, first wrap masking tape around the edges of a piece of Plexiglas or glass about 9" × 12" in size. This is your printing plate. For a larger print, use the freezer paper-covered work surface as the plate. Select a paper (most kinds will work) that is slightly larger than the plate. Dampen the paper slightly, except for rice papers.

Apply paint to the printing plate with a brush or brayer, using thinned tube or jar acrylics. Work quickly so the paint doesn't dry before you print. Spray the surface with water or alcohol to keep the paint wet or move it around. Draw into the paint or scrape with a palette knife, making any design or subject.

Wipe the taped edges before printing so you will have a crisp edge around the print. Immediately place the paper on the wet plate and pat gently, or roll with a brayer. Peel the print off the plate from one end; pull it straight back to preserve a representational image or drag and twist the paper for distortion and texture. If any paint remains, take a second (ghost) print, or add more paint for a new, unique image. Remember that the image is reversed, so any writing will appear backward.

Roll off excess paint onto other papers, which you can add to your collage palette; then wash the brayer thoroughly.

Apply masking tape along the edges of a piece of Plexiglas or glass. Then brush and spatter acrylic paint over the entire plate and spray lightly with water or alcohol to help move the paint.

Wipe along the taped edges of the plate, then cover the paint with a piece of slightly dampened paper. Roll with a brayer, then pull the paper up from one end to create the monotype.

Place another sheet of damp paper on the paint that remains, and pull a "ghost print" from the plate.

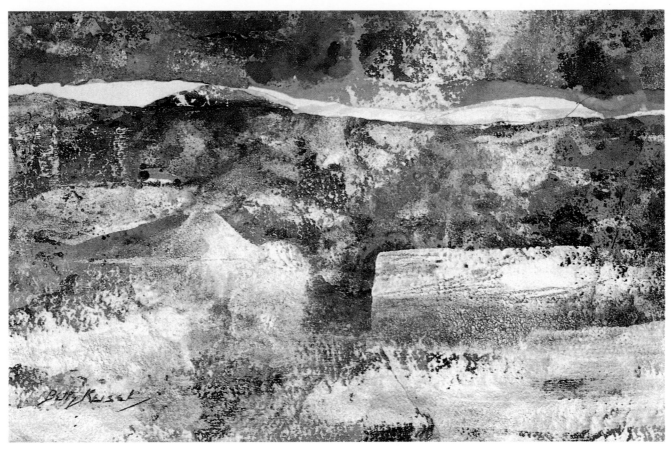

FOOTPRINTS OF THE PAST by Betty Keisel. Water media monotype collage, 15″ × 19″.

Acrylics and watercolors were combined with concentrated powdered pigments and interference paints to make the monotype used in this collage. You can use any combination of water media to make a monotype. Experiment and see what happens. The monotype creates a more subtle texture and blending of color than direct brushstrokes would, adding mystery to the artwork.

DEMONSTRATION THREE: Collage With Mixed Media

We decided it would be fun to do something less structured than the previous demos, so we used a potpourri of materials and techniques from projects in earlier chapters. We had no drawing and no definite design plan. All the same, we thought about movement, pattern, dominance and color, among other design considerations, as we assembled an "art-o-biographical" collage based on the two of us as artists.

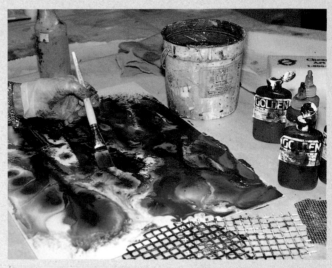

STEP ONE. All sorts of items have interesting possibilities for an "art-o-biography": bumper stickers, brochures, magazine advertisements and logos, all based on an art theme. Each of us contributed things that have some particular importance to us as artists. We assembled these materials, then put them aside to prepare the background.

STEP TWO. Although we didn't expect much of it to show, we wanted a richly colored, dark background to contrast sharply with the brightly colored materials we selected for our collage. A blend of primary hues gave us some strong violets that would work with the colors of some of the materials we expected to tie in later. We applied acrylic paints to coated illustration board and sprayed water to help the colors mingle.

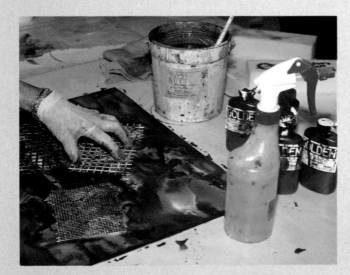

STEP THREE. We didn't want the background to get too busy, but we thought a little texture would be useful where it would show through between collage bits. We imprinted three different grids on the wet acrylic paint to provide background texture. The shapes varied enough to create interest in the areas.

STEP FOUR. The palette, which we made using the acrylic appliqué technique, provides the focal point and a cardboard glove liner sets the palette off perfectly. We collaged ribbon onto the glove and stuck a paintbrush under the finger, then began to look for other materials to coordinate with the background.

STEP FIVE. To tell our story, we selected materials we had set aside earlier. We used only a small percentage of what we had when we started. We also worked in some of the monotype we printed in Project 30, tearing it into pieces and using it to enhance the background and edges. Most of the pieces were arranged over the entire surface before anything was adhered.

STEP SIX. Once the pieces were adhered, we stepped back to study the collage. A few adjustments were made—pieces added or covered up. As a final touch, we added a rice paper cuff to the glove and tinted the glove with watercolor, so it blended in delicately with the colors throughout the collage. Other areas were also glazed lightly with watercolor or acrylic washes to unify them and simplify the design. The piece was then encased in gloss and matte mediums.

ART-R-US by Nita Leland and Virginia Lee Williams. Mixed media collage, 15" × 20".

MAKING SUPPORTS

CASCADES by Nita Leland and Virginia Lee Williams. Water media collage on watercolor board, 13″ × 18″.

Create fantastic textured backgrounds with mediums, paper and natural materials to make your collages original and exciting.

5

CHAPTER ELEVEN

Texturing Supports

Richly textured foundations add visual and tactile interest to your collages. You can create textured supports by adhering a variety of natural and man-made materials to any collage support. Incorporate small objects you find washed up on the shore or lying on the forest floor. Add natural materials, like grasses, seeds, beans, pods and herbs. Use heavier items found in treasure hunts on the streets, at building sites or junkyards. All of these require solid support. (For information on preparing supports see pages 24-25.)

All supports, except canvas, should be coated on both sides with gloss medium to minimize warping. Papers or boards that have partial rag content are recommended. Those that are described as pH neutral or acid-free are less subject to discoloration or deterioration. Papers should be 140 lb. or heavier. Boards should be three- to five-ply. The heavier thickness is less subject to warping. Heavyweight, rag-content supports are more costly than other materials, but the end result is more satisfactory. The texture of the surface, hot-press (smooth), cold-press (medium) or rough is a matter of personal taste. Try all of them.

Premixed and special-use acrylic texture mediums are available from several manufacturers. These include mediums with blended fibers, pumice, stucco or sand. However, you can easily create your own textured supports for collage; the next group of projects shows you how.

COMBINING TEXTURE TECHNIQUES

Use discretion and good taste when you make a collage support, combining just two or three techniques and establishing movements and pattern repetitions throughout the support, rather than random placement. Retain a few texturally "quiet" areas, just as you do in designing the surface collage or painting. Be selective.

CAPE OF CORNWALL by Virginia Lee Williams. Acrylic paint with rice paper, blotter paper, fabric, embossed wallpaper and gold leaf on canvas, 14" × 18".

This piece illustrates several of the techniques you'll learn in the next two chapters, including a support built up in low relief, using rice paper, wood chips, layered blotter paper, fibers and textured wallpaper. Shells, stones and sand can also be used to texture a support.

Supports for Collage

SUPPORT	TYPE	USES	PREPARATION	COMMENTS
bristol board	3- to 5-ply	adhere papers, objects	gloss medium or gel on both sides	pH neutral
canvas board	Frederix and others	adhere papers, objects	gloss medium or gel on back	gesso coated
canvas (stretched)	cotton or linen	adhere all; staple or sew on objects	gesso front surface, if untreated	cover staples with gesso; won't warp; brace back if heavy
illustration board	medium or heavyweight cold-press	adhere paper, objects	gloss medium or gel on both sides	rag content or pH neutral
Masonite	untempered	adhere heavy objects; assemblage	gesso front surface; brace back	extremely heavy
mat board	colored, textured	adhere papers, small objects	gloss medium or gel on both sides	rag content or pH neutral
plywood	any	adhere, screw or staple objects on	gesso front surface; brace back	extremely heavy; not recommended
printmaking paper	140 lb. or heavier	adhere papers, small objects	gloss medium or gel on both sides	rag content or pH neutral; may be stretched
watercolor board	heavyweight; cold-press or rough	adhere paper or heavy objects	gloss medium or gel on both sides	rag content or pH neutral
watercolor paper	140 lb. or heavier; any surface	adhere papers, small objects	gloss medium or gel on back	rag content or pH neutral; may be stretched

PROJECT THIRTY-ONE: Creating Distressed Paper Supports

The technique featured in this project is called *déchirage*, which refers to the tearing or peeling of heavyweight papers into layers. You can use this technique to make layered or textured supports that are three-dimensional or sculptural. The best paper to use is 300 lb. rough Indian handmade paper, which is thick and heavily sized. The paper is available from the Daniel Smith catalog. (See the Appendix for this company's address.)

Experiment on a small piece of paper. With a utility or stencil knife, lightly score the paper. Pick at the edge of the cut with the point of the knife and loosen the edges. Then peel back small layers of paper with your fingers. Score again in the next layer. The layers cast shadows and develop intriguing patterns as you cut and peel. You might try cutting completely through the paper to create openings. Coat the peeled layers with matte gel medium and manipulate the shapes while wet.

Adhere the peeled paper to a support. If the support has been painted or collaged, let the background colors show through the openings in the peeled paper or adhere objects in the openings. Paint the peeled paper with a thin wash of acrylic or watercolor paint; then scumble other colors, rough-brushing over the support, or spatter and pour thin paints over the surface. To make the peeled paper look like twisted metal, use metallic or iridescent paints. Create a rusty look with earth reds. Experiment. You'll love it.

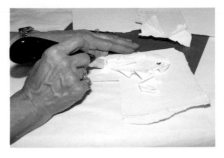

The first step in *déchirage* is to score heavy, handmade Indian Village paper with a utility knife and peel back a layer of paper. Repeatedly score and peel more layers.

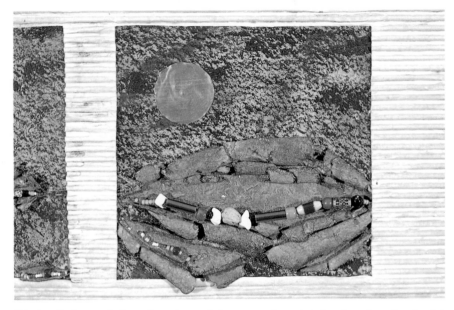

This detail of artwork shows how the peeled paper can be painted and used as a focal point with collage materials adhered to it.

PROJECT THIRTY-TWO: **Texturing Supports With Mediums**

Acrylic mediums are terrific for imprinting patterns and textures right on the support, giving a dimensional effect. Use a strong support, such as stretched canvas or watercolor board that has been coated on both sides. The canvas is sturdy and lightweight, a major consideration if you work large and ship your work.

Prepare a mixture of 50/50 modeling paste and gel medium. The gel is essential, preventing the paste from cracking as it dries. The mixture remains flexible and can also be used to adhere heavier ob-

jects, such as stones, shells and metal pieces.

Apply the mixture thickly to the support. Imprint the surface with some of the objects, such as berry boxes, bottlecaps, bubblewrap, combs, keys and heavily textured objects. (See the Appendix for other ideas.)

Embed some of the objects in the medium and leave them. Draw into the wet medium with a stick or brush handle, or texturize the surface with a paint roller. You can twist string around your roller to make an interesting pattern. As

you select objects to embed and imprint, repeat some textures and shapes to create consistency in design. Arrange them on the surface to direct eye movement around the piece.

Let the surface dry overnight, then gesso two coats over it for a pure white, opaque support. Paint and collage on your textured support. If you want some items to retain their natural look, adhere them after you have applied the gesso or paint.

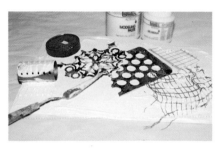

To create a textured support, gather together an assortment of textured materials that will leave a deep mark in a gel/modeling paste mixture.

Coat the finished support with gesso and it's ready to paint and collage.

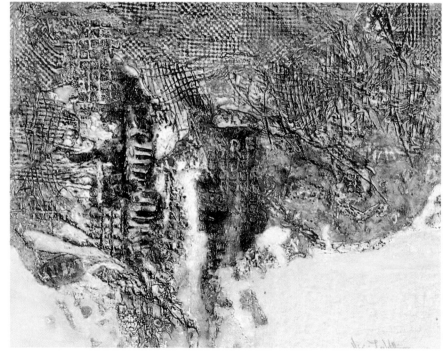

LITHOSPHERE by Virginia Lee Williams. Acrylic paint on textured canvas support, 16″ × 20″.

This canvas support was textured with embossed shipping material, blotter paper, sand and corrugated cardboard, then collaged and painted with acrylics after the support was thoroughly dry.

PROJECT THIRTY-THREE: Creating a Layered Support

Although all collage is layered, this low relief surface is special, because the layers absorb paint differently for beautiful and surprising effects. For this project use untextured blotter paper to build up a low-relief surface. Art supply stores, catalogs and paper supply companies carry blotter papers that work well. The James River brand Verigood blotter paper tears with beautiful feathered edges. Experiment with other papers, too. Office blotters are usually too thin and don't peel or tear well.

Tear the blotter paper into a variety of shapes. Coat the back of each piece heavily with gel or matte gel medium and adhere in several layers to a stretched canvas support. Stagger the edges and distress the paper by tearing holes in it as you build up the layers. It isn't necessary to dry between layers. While the layers are still wet, you can move them around and insert pieces between them. You can also rub the layers with your fingers to roughen them and add more texture. Then, you must let the finished piece dry overnight. The result will be a white-on-white dimensional surface that suggests mountain ranges, rock formations and abstract organic shapes.

Coat the surface with two heavy applications of gesso, allowing each coat to dry thoroughly. Let this surface dry overnight.

Next, thin acrylic paint with water to the consistency of a watercolor wash. Spray the layered surface generously with water, then brush, spatter and drip two or three colors onto it. Spray the paint to move it around the surface and into the crevices. Give it

Untextured blotter paper works well for creating a low-relief surface. Tear the paper into strips of varying widths, lengths and shapes.

Coat the back of the torn blotter paper heavily with gel medium and adhere in layers to a canvas support, then coat the dry layered piece with gesso. The layers cast shadows where they are heavily built up.

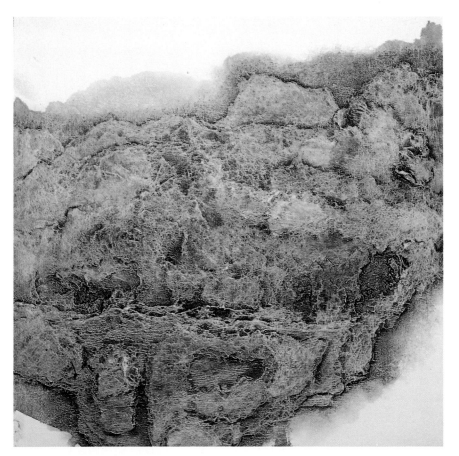

After the gessoed surface dries, apply thin acrylic washes and spray with water. The paint will settle beautifully in the crevices between the layers.

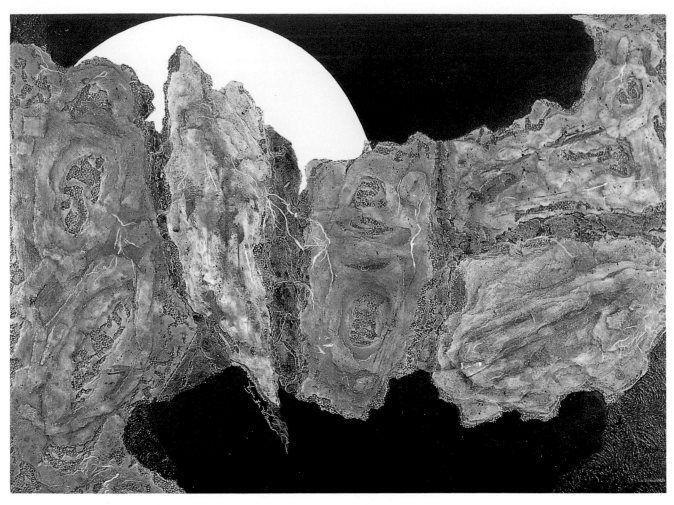

CHASM SPAN SERIES III by Virginia Lee Williams. Acrylics on distressed, layered blotter paper collage support, 30″ × 40″.

In this collage the background of a layered blotter paper support was painted black with acrylics for dramatic effect. This piece also includes layers of tinted rice paper.

time to sink into the layers, then let it air dry. As the water evaporates, the paint soaks in, leaving a highly transparent paint layer. Scumble or dry brush with contrasting colors.

Layers absorb paint differently, with some holding more color than others. This unpredictability is part of the beauty of layered collage. Stand back occasionally to evaluate the overall effect of the collaged layers. Shine lights from various angles on the piece to study shadow effects. Introduce additional layers of blotter paper,

paint and collage where needed. Develop a focal point in the areas having the most intense color and interesting textures. When the layered collage is finished, coat it with gloss medium or gel and finish with matte varnish to bring out the colors.

You can also do the layering process on the waxed side of freezer paper, dry the pieces, then peel them off and collage them to a support; or you can use them to introduce texture into a watercolor painting or to enhance a paper collage.

CHAPTER TWELVE
More Textured Supports

Natural materials and found objects provide literally unlimited resources for incorporating into collage. They also connect with environmental thinking, because materials are put to use instead of being disposed of. Often, when these materials are used to create a support, they make such interesting surfaces that the support becomes the feature of a nature collage. The random textures of natural materials also make beautiful backgrounds for collage, providing a dimension not possible in most painting mediums. Traditional collage materials can be integrated into the textured surface, which can be left unpainted or coated with gesso and painted. The play of light and shadow on a textured surface adds an intriguing element of mystery.

Finding suitable materials calls for creative awareness on your part. Look around you and see what is at hand that you might not ordinarily use for collage supports. Collect sand and shells from beaches, chips and shavings from a workshop, small bits and pieces of rusty, twisted metals or hardware found on the sidewalk. How about dried peach pits, lint from the dryer, twigs and dried flowers? Make a list of possibilities.

Take a walk right now and see what you can find. Notice the shapes of things, the richness of textures; see the beautiful colors of rust and oxidized metal scraps. Visit a junkyard and come away with a wealth of material. In the projects that follow, you will find ways to put these materials to artistic use as textured collage supports and, in chapter fifteen, in an environmental collage.

Many of these materials will need to be prepared for use. Brush off rust or dirt and wipe woods and metals with a cloth dampened with water or alcohol. Coat with gloss medium or gel. Sift sand through a strainer if it has too much foreign matter in it.

Use a solid support for these materials, and coat both sides of the support before beginning the texturing process.

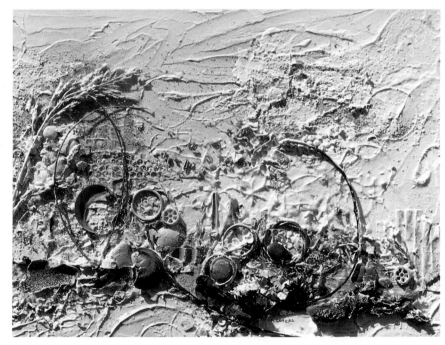

BALLET by Marilyn Coppel. Mixed media collage with acrylics, natural materials and found objects, 12½" × 14½".

The bounties of nature, with their elegant textures and forms, make wonderful collages.

PROJECT THIRTY-FOUR: Making Sand-Textured Supports

Add a pile of sand and a kitchen strainer to your growing supply of tools and materials for collage. Any kind of sand will do, whether you dig it out of the sand pit, haul it from the beach, or buy it at the craft store. It really depends on how rough or dark in color you want the surface to be.

Use a firm surface — stretched canvas, board or heavy paper — to support the weight of the sand. Mix the sand with gel medium to a spreadable consistency, something like soft peanut butter. You want it to hold its shape as you work with the mixture.

Spread the sand-and-medium mixture over the support with a palette knife. Print into it with rollers, draw into it with sticks, press your hand, jar lids or other textured objects into it while it is wet, or embed small objects in it for dimensional effects. When the surface is thoroughly dry, you can leave it natural as a background for a nature collage with shells, stones and dried plant materials; or paint it with two coats of white gesso and proceed with other collage processes. This highly textured, grainy surface takes paint and collage well. Store any excess mixture in a tightly covered glass jar.

Another way to use sand in collage is to sift gritty sand onto watercolor paper that has been heavily coated with still-wet matte medium. When the surface is dry, shake off the excess sand and tear the paper into pieces to add to natural collage surfaces.

BIRCH STAND by Pat Dews. Acrylic on canvas with papers, sand and gravel, 48" × 36". Collection of Dr. and Mrs. Arnold Lipschutz.

The sand embedded in the lower area of the support adds dimension and reality to this collage painting.

This photograph shows three sand-coated supports created by (left) sifting white sand onto wet matte medium; (center) using darker sand on a support; and (right) painting a sand support.

A second method using sand is to create a spreadable sand mixture by mixing the sand with gel medium, then scooping it out onto the support and spreading the mixture with a palette knife.

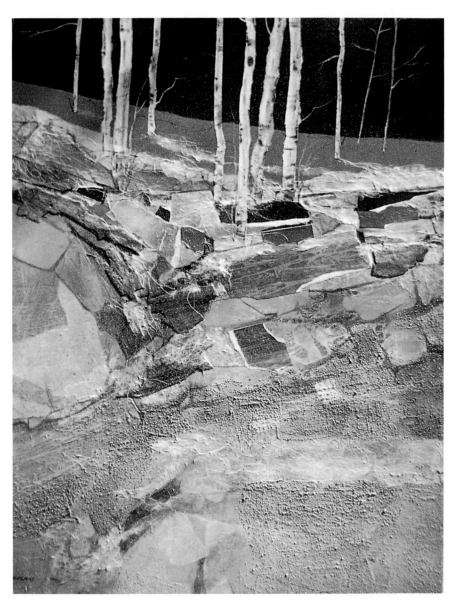

PROJECT THIRTY-FIVE: Using Wood Shavings or Chips

Create a lovely naturalistic collage by mixing wood materials with medium. Take advantage of the true colors of the materials or add paint and collage to this wonderful textured surface. It's easy to do. Use illustration or watercolor board, stretched canvas or 300 lb. watercolor paper.

Go to your local woodcarver, handyman or lumberyard and ask for wood shavings and chips. Shavings come in all sizes and shapes, some short and curly and others long and stringy. You can also use sawdust, if it isn't too fine. Look for wood chips that have been trimmed from the ends of thin strips of wood trim. Get small chips, not large ones. Also, look for circular, oval and triangular cutouts from jigsaws.

Use one of these three ways to make the textured support:

1. Brush gel medium onto the support and sprinkle shavings or chips lightly over it. Shake off excess material when the support is dry. Coat with gloss medium or gel.
2. Spread a heavy coat of gel onto the support and press wood chips into the mixture. Coat with gloss medium or gel when dry.
3. Put shavings in a jar with gloss medium and stir till the shavings are fully coated and spreadable. Spread the mixture on the support and create textured shapes. Dry thoroughly.

Whether you stir the shavings into medium or coat them heavily after you apply them, make certain that all wood chips and shavings are thoroughly coated with medium, so the acid in them can't mi-

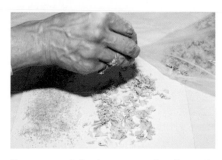
To use wood shavings or sawdust in a collage, sprinkle them onto wet gel medium.

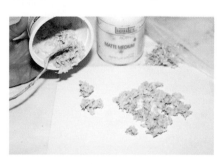
Another method is to mix wood shavings with gloss medium and scoop the mixture out onto the support, patting it gently in place.

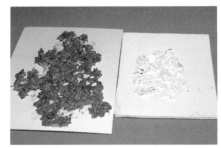
When dry, leave the adhered shavings natural or coat them with gesso.

UNCLE GENE by Nita Leland and Virginia Lee Williams. Acrylic matte gel and wood chips on mat board, 10" × 7½".

Add a touch of whimsy to a collage with wood chips from a jigsaw.

grate onto the support.

To complete a naturalistic collage, add other natural materials, such as dried leaves, weeds and flowers, shells or unpainted rice papers. Visit your friendly neighborhood floral designer and perhaps you can beg or buy less-than-perfect silk or dried flowers and foliage or floral items to use in your collages. Fall is the perfect time for you to collect your dried natural materials.

Be sure you encase all natural materials in gloss medium or gel before using them in collage. Soak dry leaves or bark in warm water. Pat them dry. Coat both sides with medium, drying thoroughly between coats. Dip dried flowers or weeds in diluted gloss medium to hold their shape. If your materials are too fragile to withstand dipping or brushing, they are too delicate to be used in collage.

To use the natural textures as a background, brush the natural collage surface with two coats of white gesso, then paint or apply other natural materials and collage papers to the textured support.

WINTER'S SNOW SPELL by Jane Cook. Watercolor and gesso collage with wood chips and found materials, 25½" × 31½". Collection of Mr. and Mrs. Clayton Smith.

Wood chips coated with gesso suggest crusty ice and snow perfectly in this winter abstraction. Nothing else would give quite the same effect.

PROJECT THIRTY-SIX: Applying Fibers to a Textured Support

Dig into your rag bag for this one. Any material that has fibers is fair game: sailcloth, lace, cheesecloth, burlap, webbing, netting, rope, string and vegetable bags. Coarse fibers are particularly effective. Most fiber textures work well with natural materials. An interior design shop may sell you sample books or remnants of textured fabrics at a reasonable price.

Tear holes in the fibrous materials or fray the edges to add interest to the pieces. Save the fibers that you pull out to use somewhere else in the collage. Brush matte gel medium on the back of solid, heavy materials, then on the support. Pat the fabrics into the medium on the support, arranging rhythmic, flowing shapes charac-

teristic of the material. The damp fibers are usually pretty pliable and can easily be manipulated. Combine fibers, textures and patterns, but remember to select a dominant element and repeat it with variations.

When the fiber support is dry,

apply two coats of gesso, then paint and collage over it. You can make smaller fiber pieces by applying fibers to watercolor paper, as described above, then tearing up the papers and adhering them to any support.

The cheesecloth, burlap, yarn and hand-loomed fabric shown here are just a few of the fibers you might use in collage. Others are mesh bags, yarns and ribbons, or heavily textured fabrics.

REMNANT GLOW by Pam Brooks Zohner. Water media with cloth and natural materials, 27½" × 42".

This design is unified by color and the repetition of the block pattern. The pulled fibers at the edges create an exciting tension that prevents the design from becoming static.

DEMONSTRATION FOUR: Working With Textured Supports

This demonstration provided an opportunity to combine several different textured supports in a nature collage with an abstract design based on horizontal bands. A solid design structure lay beneath the materials on the textured surface. Once we established the design and selected the materials for the basic textures, we let the collage evolve and then finished it with an intuitive approach.

STEP ONE. First, we made several design sketches based on parallel lines to suggest stratified layers. We wanted different widths and planned to use different textured supports in each area, with a secondary focal point in each band. We transferred our final design to the canvas support.

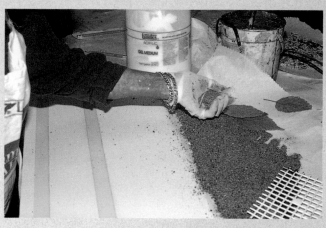

STEP TWO. After taping some of the edges to mask the strips dividing the design segments, we sprinkled dark sand into a heavy layer of matte gel in the top band and pressed encased leaves into the sand. The leaves were placed symmetrically across the top, with one leaf turning down to provide a contrasting movement. One of the leaves was allowed to overlap the strip below.

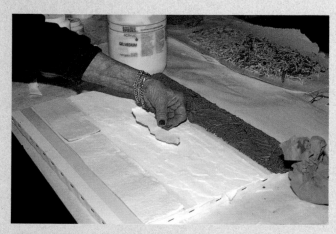

STEP THREE. We layered the next wide band with blotter paper. This step took awhile to complete, since we first tore and arranged the paper in different ways to get a nice landscape feeling to it. After the layers were adhered and dried, the surface was gessoed and allowed to dry again before painting.

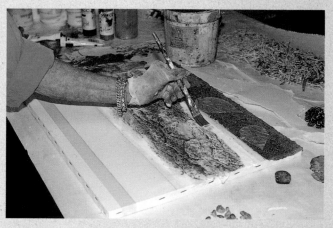

STEP FOUR. Thin acrylic washes of earth-toned primary colors were brushed onto the layered surface. The surface was sprayed with water, and again we waited until the paint settled into the crevices of the layered blotter paper and dried. Darker colors were then scumbled and dry-brushed over the surface.

STEP FIVE. We sprinkled on a few wood shavings (coated with medium) for more texture, then we removed the protective strips of tape from the narrow bands. For the next wide band we made a *déchirage* strip with three openings from Indian Village paper and tinted it with acrylic washes.

STEP SIX. We adhered three natural stones within the openings. Picking up a color from the layered section, we painted the narrow strips between the textured bands a solid blue-violet, giving an ambiguous earth-sky-water look to the whole piece. We placed the focal point, a woody stem adhered with matte gel, then underlined the lower band with strips of bark. The stem was weighted down until dry. Since everything used had been coated with medium, no final coat was applied.

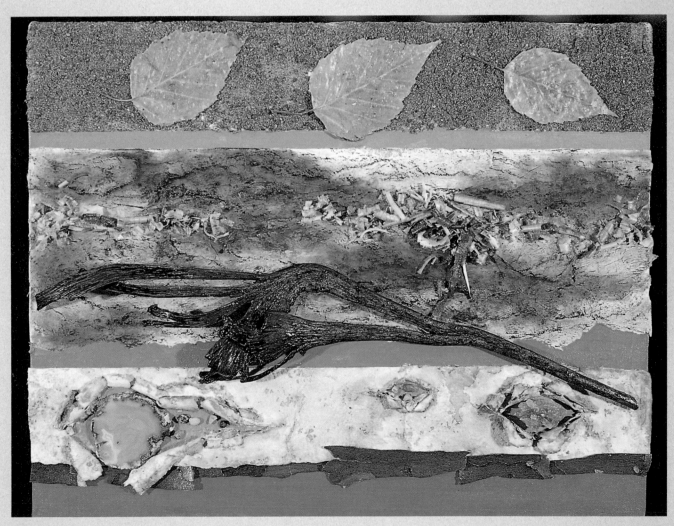

AUTUMN SONG by Nita Leland and Virginia Lee Williams. Mixed media collage, 16" × 20".

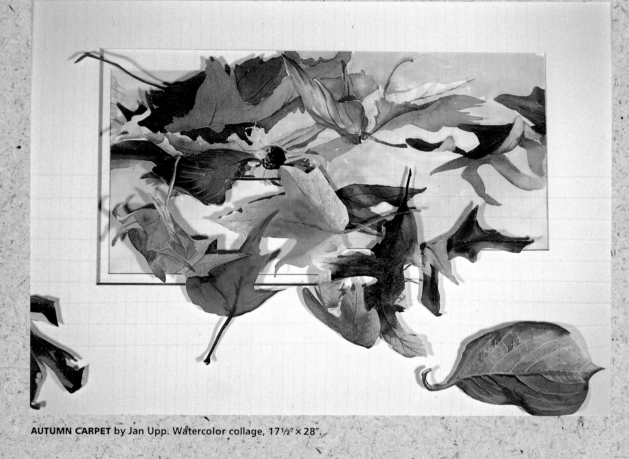

AUTUMN CARPET by Jan Upp. Watercolor collage, 17½″ × 28″.

Make elegant and distinctive papers with paints, pulp and mediums, and use them to create unique collages.

Customized Collage Papers

Collage techniques are really quite simple, aren't they? You coat a support and adhere papers and other materials to it. The ready-made papers available at art supply stores are richly varied, with brilliant colors, exciting textures and many different weights and finishes to choose from. You haven't seen anything yet! You can create your own customized collage papers, unlike anything you might see in a shop.

The next two chapters are filled with projects in which you will make unique collage papers. The projects aren't difficult; we have simplified these techniques to their most basic components, just to get you started, then you can invent your own variations. You'll do projects that enhance your collages, experiencing new tactile sensations with brayer papers, exploring color schemes with crystalline papers, designing exotic collage papers with natural materials encased between layers of rice paper. You'll learn even more about the versatility of acrylic mediums, making free-form shapes you can use as focal points in your collages. This is creativity at its best, flourishing with little more than acrylic paints and mediums, a brayer, rice paper and tissue paper. Get ready

for a creative trip through the funhouse!

Occasionally, you can use an elegant piece of your customized paper as your inspiration for an entire collage, developing color ideas or expanding on rhythms found in the paper; sometimes you can use these papers as the dominant element that unifies your collage. However you use your customized

paper, just remember that no one else has access to anything like it, because you made it yourself.

Set aside a special day in your studio for preparing your papers according to the techniques that follow, and then use them in a specific collage or store them for future use. The techniques are easy, but to get satisfactory results, follow instructions carefully.

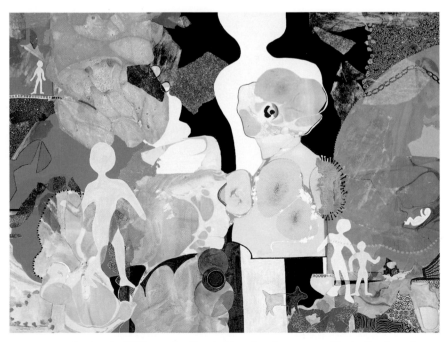

DIMENSIONS by Juanita Williams. Acrylics and handmade paper on illustration board, 30″ × 40″.

Using techniques you will learn in the next two chapters, Williams made this collage with her own handmade brayer and marbled papers. Everything repeats the organic flow of the marbled papers, with an unusual figurative emphasis in the collage. These humanoid shapes dominate the design.

PROJECT THIRTY-SEVEN: **Making Brayer Papers With Gesso**

You can make exquisite collage papers with body and texture, using Niji Craft Pack or any other good quality white tissue. Cheap wrapping tissue will not hold up. To make the tissue easier to handle, cut each sheet in half (15″ × 20″).

To begin this two-step process (the second step, painting the brayer paper, is in the next project), lay one of these half-sheets flat on your freezer-paper work surface. Spoon a large amount (about a cupful) of white, black or colored gesso on your freezer paper near the tissue. Gently roll a 3- or 4-inch soft printmaker's brayer in the gesso until it is evenly and heavily coated. Place the brayer in the center of the tissue paper and lightly roll gesso out to the edge. Easy does it; do not roll the brayer back and forth. Coat the brayer again and roll it over a different area of the paper from the center out, repeating this process until the sheet is completely coated. When you finish coating all your papers, scrub the brayer throughly to keep it soft.

Carefully pick up the wet paper and move it to a separate piece of clean freezer paper to dry. To prevent sticking, lift up the corners and edges frequently as it dries. The first coat will take longer to dry than subsequent coats. Let the paper dry naturally, then coat the back. The leathery-textured coated paper is no longer so fragile. Brayer additional coats of gesso if you want heavier paper. To paint your brayer paper, follow the instructions given in the next project.

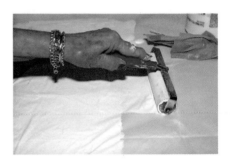

You can make exciting collage papers easily by rolling gesso on good quality craft tissue paper, from the center to the edges. For heavier paper, simply roll more coats, allowing each coat to dry before applying the next coat.

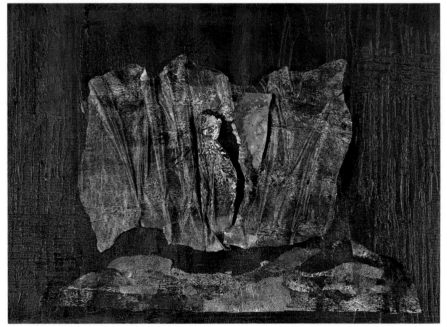

EARTHLY ESSENCE by Dorothea M. Bluck. Mixed media collage with brayer paper, 18″ × 24″. Private collection.

This piece may look like oxidized metal on wood, but it's really brayer paper on textured canvas. A bit of real copper was used as an accent.

PROJECT THIRTY-EIGHT: Painting Your Brayer Papers

You can achieve many beautiful effects with painted brayer papers, depending on how you combine the colors and which color is laid down first. The paint rolls unevenly on gesso-coated brayer paper, making a broken layer of color through which previous layers of color are partially visible.

Plan a color scheme and limit the number of colors you use to four. If necessary, thin your paints with water or matte medium to the consistency of sour cream. Pour one of your colors onto the freezer paper. Coat the soft printmaker's brayer evenly with paint. Lightly roll the brayer from the center out to the edges of a sheet of gesso-coated brayer paper to deposit a broken layer of paint. Vary your pressure on the brayer to create variations in the texture, color and value. Dry your brayer paper with a hair dryer.

Wash the brayer thoroughly to remove all color, rolling it dry on a folded towel, before repeating the process with another color.

Repeat the brayering process with other colors, alternating layers of light and dark colors, rolling on each layer of paint, and then drying the paper between applications. For different effects, you can place lace, mesh bags and stencils on dry brayer papers and roll your paint over them to print textures. If you wish, you can brayer both sides of the paper with contrasting or harmonizing colors, then mix and match these papers in your collages. You can also brayer with a final coat of iridescent acrylics to enhance the color effect of your paints. Tear your brayer papers into smaller pieces and use them in your collages.

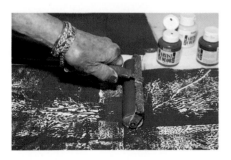

To paint brayer paper, roll a layer of acrylic paint on the gessoed paper from the center out to the edges, then when this coat is dry, roll a second coat over it in the same manner. Add a third coat of interference color, if desired.

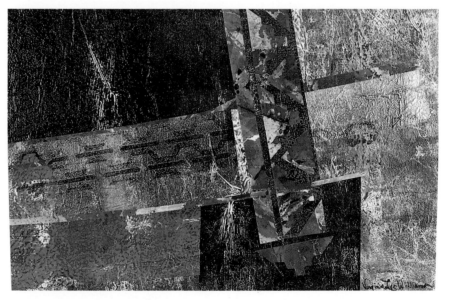

DESIGNING PATTERNS by Virginia Lee Williams. Brayer paper collage on illustration board, 14″ × 20½″.

Brayer papers are wonderful to work with, having a leathery texture that belies their origin as tissue paper. Use brayer papers as background elements or collage materials in either realistic or abstract design.

PROJECT THIRTY-NINE: Making Crystalline Paper

Richly colored crystalline papers, which are transparent and have the look of stained glass, are more exciting than any collage material found in an art store. Gloss medium makes the tissue paper transparent and intensifies the paint colors.

Cut the tissue sheet (Niji Craft Pack or some other high-quality craft tissue) into quarters (10″ × 15″) and place a sheet on a clean freezer-paper work surface. Use a 1½-inch or 2-inch soft synthetic brush to coat the tissue heavily with gloss medium, brushing gently from the center to the edges. The paper will crinkle slightly. Allow it to air dry, lifting the edges once in awhile to see that it doesn't stick to the freezer paper. Carefully turn the dry paper over and apply a coat of gloss medium to the back. Allow the paper to dry naturally, lifting the corners and edges occasionally so the sheet can be easily removed from the freezer paper when it is thoroughly dry.

Spray the dry, coated paper with water, then brush or pour thinned or liquid transparent acrylic colors on the surface, allowing the paint colors to mingle and flow. Be sure to use pure, bright colors. If you like, you can sprinkle iridescent snowflakes or glitter into the wet acrylics before you set the tissue aside to dry. The painted side will be a bit brighter in color than the other side. Dust the dry paper lightly with cornstarch to store.

You can use these papers as contrasting textures in your collages (for example, combined with novelty wallpapers), as an elegant overlay on gold or silver paper, or as a glaze over colored backgrounds. The underlying colors will show through the transparent crystalline paper. You can also frame a free-hanging crystalline collage, sandwiched between pieces of glass, to be viewed from both sides.

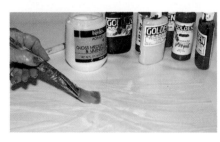
Creating crystalline paper is a simple process. First, brush gloss medium on tissue paper with a big brush, from the center to the edges. Let it air dry. Coat and air dry the back of the paper also.

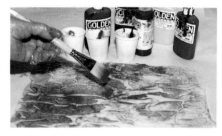
Spray the dry paper with water; then brush on acrylic paints. When dry, the paper will look like colored glass.

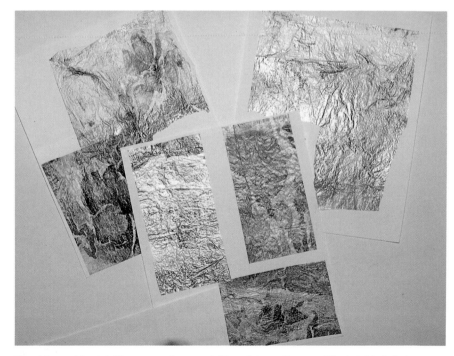
The shiny gold crystalline papers have metallic paints on them and the bright pinks incorporate iridescent paints.

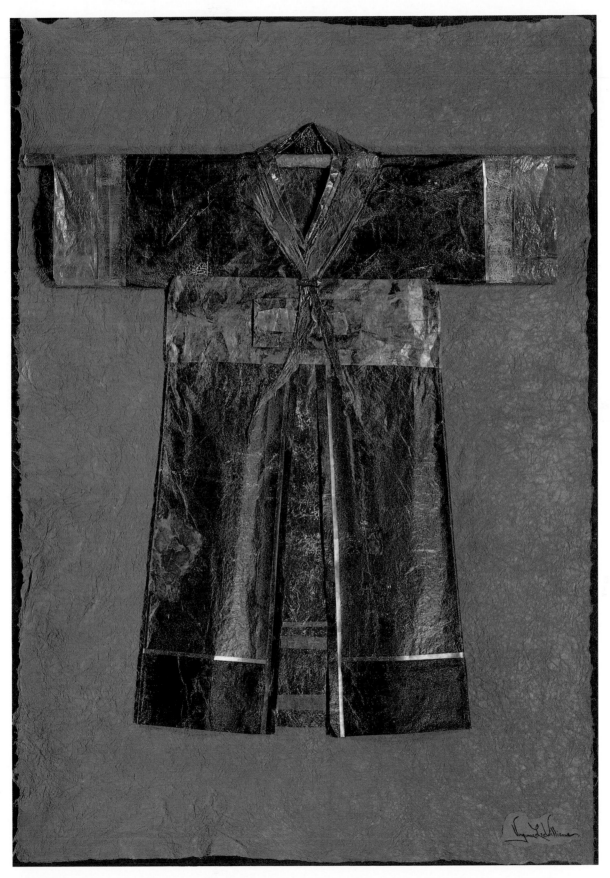

AWAITING by Virginia Lee Williams. Acrylic paints on brayered tissue and rice paper on illustration board, 35″ × 24″.

This interesting piece is a combination of shaped brayer and crystalline papers that have been accented with gold trim and peeled paint.

PROJECT FORTY: Creating a Crystalline Free-Form

Here's another easy crystalline process. First, gather a number of small, colorful objects, which you will eventually embed in the free-form shape you make; look for objects such as gold or silver string, ribbon, painted sticks, metal shavings and dried floral materials. Use either Golden Fluid Acrylics or Dr. Ph. Martin's Spectralite for this project. Plan a color scheme of three or four colors.

Tape a sheet of freezer paper, plastic side up, to a 14-inch square piece of mat board or heavy cardboard. Lay the board flat on the work surface. Mix gel medium and gloss medium about 50/50 to a creamy consistency that will hold a shape. Do not use matte gel medium, because it will not be crystal clear when it dries. Spoon the mixture onto the freezer paper board, creating an interesting shape about eight to ten inches in size by ¼-inch thick. Leave a few openings in the shape as you spread the medium. With an eyedropper, drop small amounts of color into the wet mixture. Stir the colors gently with a toothpick to create a swirl pattern, bringing color to the edges of the form. Gently press small objects into the shape.

Set the board aside to dry on a flat, even surface, until the shape is transparent. (Note: Acrylic mediums appear milky until completely dry.) This will take several days. Don't try to speed the drying in the sun or with a hairdryer or the shape will shrivel up like a raisin. Peel the dried shape off the board.

Although not a collage paper, the crystalline free-form combines beautifully with crystalline and brayer papers, as well as other materials, in your collages. After you experiment with the basic procedure, invent your own variations. What might happen if you used matte instead of gloss medium? If you combined the two mediums in a swirling pattern? If you used soft neutral colors instead of bright hues? If you embedded sticks and stones instead of glittery things? Let your imagination play.

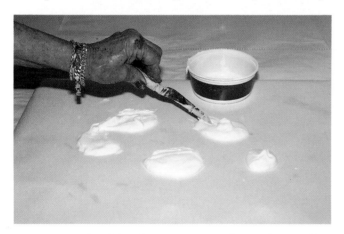

Pour out several puddles of a creamy 50-50 mixture of gel medium and gloss medium. Shape them with a palette knife into one form, about 8 inches around and ¼ inch thick.

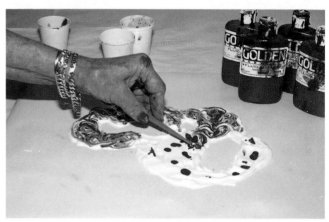

Drop paint here and there on the wet form and tease it into swirls in the medium with a toothpick or small stick.

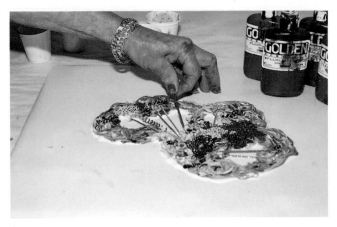

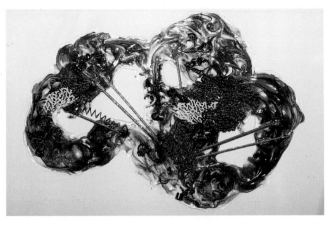

Gently add beads, bits of metal or colored sticks, and press lightly in the free-form.

Allow the free-form to dry flat until the medium is transparent. This will take several days. Use it as a focal point in a collage.

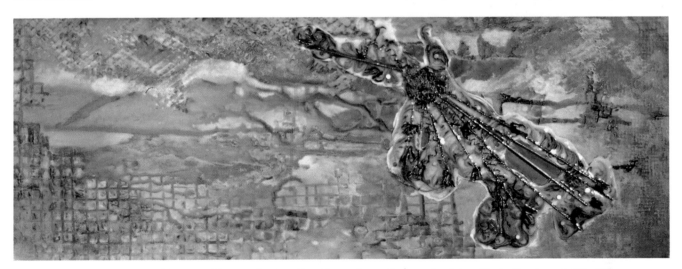

PRISMATIC OVERTONES by Virginia Lee Williams. Mixed media with acrylic mediums and paint on illustration board, 11" × 28". This crystalline free-form serves as the focal point on a background of printed textures.

PROJECT FORTY-ONE: Encasing Materials in Rice Paper

You can purchase rice paper that has leaves, butterfly wings, fibers, wood chips and other natural materials embedded in it—or you can easily make your own. In previous projects you employed the encasing process to seal your collage materials with medium to protect them from exposure and deterioration. In this project you will encase natural materials within a sandwich of transparent rice papers for a lovely customized collage paper.

First, gather an assortment of natural materials that are relatively flat. (See the Appendix for ideas.) Use white unryu or any other relatively transparent rice paper; the lacy textures work nicely with this process.

Use two small sheets of rice paper about 8″ × 10″. Lay the papers on freezer paper and coat one side of each sheet with gloss medium. While the paper air dries, lift the edges gently from time to time to prevent sticking. Coat the other side of one sheet liberally with medium. Place your dry natural materials on the wet medium. You can create a mini-composition, if you like, or make interesting all-over patterns. Coat the uncoated side of the second sheet heavily and lay the wet side down on top of the materials. Roll with a brayer, pricking air bubbles with a pin to force air out, and roll again. Lay the finished piece on freezer paper to dry overnight.

To store your encased rice papers, first dust them with cornstarch to prevent sticking. Use them to enhance your collages, particularly those with natural themes.

To start the encasing process, coat one side of rice paper with gloss medium and let dry. Then coat the other side with medium and place leaves on the wet medium. Cover with a second sheet that is also wet with medium on the side placed against the leaves.

Roll a brayer over the piece to bond the leaves and rice paper together.

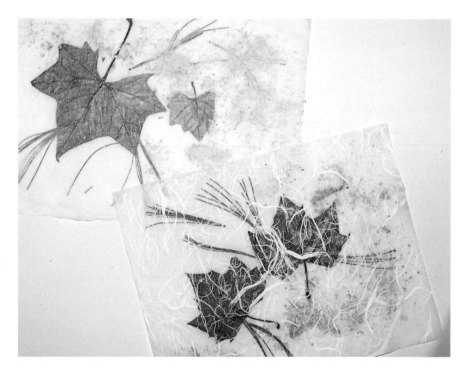
Use the encased leaves as a small composition in itself or as a focal area in a larger collage.

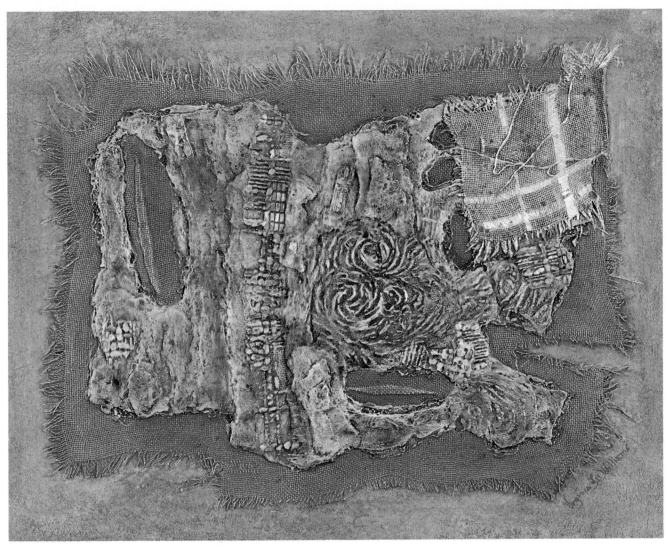

FRAGMENT by Virginia Lee Williams. Acrylic collage with fabric, embossed wallpaper and layered blotter papers on canvas, 16″ × 20″. By using acrylic paints and mediums in every step of collage, the piece becomes completely encased and protected.

Marbled and Handmade Papers

Throughout the centuries tradition has dictated the proper methods of the ancient art of marbling, the process of pulling a print from swirling colors floating on a viscous liquid bath. There are even specific marbling patterns with traditional names. It's fun to experiment, though, so in this chapter we'll show you some shortcuts that work for us, which will give you satisfactory results with just a little effort. Your marbled papers will give your work originality and distinction.

Another technique in this chapter, embossing, is the transferring of a low-relief impression of a dimensional shape to damp paper, a relatively easy process calling for simple tools. The challenge of the embossing process is designing and preparing a suitable "plate" from which to make the impression.

You will also learn how to mold paper around three-dimensional objects to create cast paper pieces that add low relief or sculptural effects to your collages. Such three-dimensional pieces cast dramatic shadows and provide a note of surrealism in your collages.

Here also is a very simple handmade paper process you can do in your kitchen or utility room, using materials you can find readily around the house. The added benefit is the recycling aspect of the process, as you will use only old newspapers or other soft, absorbent papers.

We have discovered relatively easy methods of doing these processes; then you can decide for yourself if you want to go on to more complicated procedures. After you have made your beautiful marbled, embossed, cast and handmade papers, use them in your collages as fantastic focal points and fascinating backgrounds. Think of the possibilities!

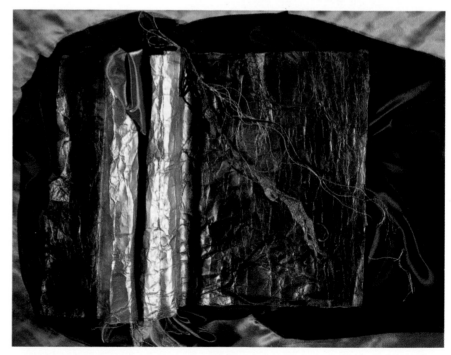

GEORGETTA'S FOLDS AND GULLIES by Rosemarie Huart. Handmade paper collage with paint, thread, silk and satin, 24″ × 30″.

The handmade papers in the focal point of this elegant piece were made from a blend of abaca, cotton and kozo fibers using a papermaker's mold and deckle. Then the pieces were shaped and painted with metallic paint and arranged on a satin background. Silk fibers and threads completed the design.

EPHEMERIS I by Virginia Lee Williams. Marbled charcoal paper, gold powder and acrylic paints on acid-free mat board, 18" × 11".

Marbling is another technique for making your own customized papers for collage. The beautiful organic patterns of free-form marbled papers can be enhanced with painted areas, extended with rhythmic lines, and then used as a background for other collage materials.

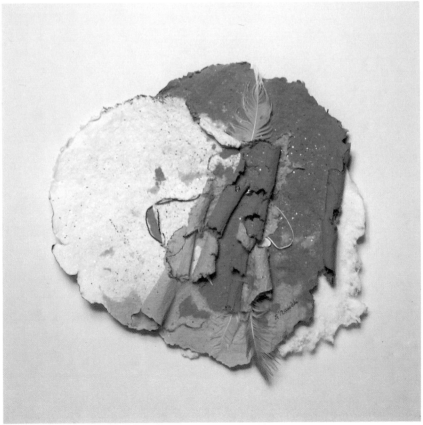

SPIRIT SHIELD by Stephanie Nadolski. Handmade paper collage with found objects, 14" × 14".

This beautiful paper was made from cotton linter, with objects embedded during the formation.

PROJECT FORTY-TWO: Marbling Papers for Collage

Marbling is easy. It does take preparation, however. Collect a group of artist friends to share tools and materials with; work through the steps together. It's fun to share the *ooh's* and *aah's* as you pull the marbled pieces from the bath.

Prepare the papers and the marbling bath (or "size") the night before marbling. For the bath, place three quarts of distilled water in a large rectangular pan (a plastic dishpan or litter pan). Sprinkle one scant tablespoon of Metalyn dry cellulose wallpaper paste (not vinyl paste) per quart of water and beat well with a wire whisk. Whisk every ten minutes, four more times. Feel the solution for granules at the bottom of the pan and stir. Wipe the edges of the pan to mix in any granules that cling to the sides. The bath should be clear and should be the consistency of liquid laundry starch. If it seems too thick, add a small amount of distilled water. Dip out one quart of the bath mixture with a glass or plastic measuring cup and set aside to add later if needed. This solution will keep for several weeks if you store it in a tightly sealed glass jar to prevent evaporation.

You can use almost any paper (charcoal, pastel, bristol, watercolor, printmaking), any weight (80 lb. to 140 lb.) and any surface, except rough. Medium- to heavy-weight textured rice papers also work well. Try some colored papers, as well as white. Coat your papers with alum the night before marbling, so the paint will adhere properly to the surface. First, mark the back of each piece with an X, so you know which side is treated. Mix two tablespoons of alum in one pint of hot distilled water. Stir till dissolved and let cool. Store in a plastic or glass container and label clearly. The solution is caustic, so keep it out of the reach of children.

Dip a cellulose sponge in the alum water, lightly squeeze out excess water (use plastic gloves or heavy-duty hand cream to protect your hands from the drying effects of the alum solution), and wipe over the unmarked side of the paper to coat the entire surface. The paper should be damp, not wet. Dry each sheet, then stack the papers neatly, treated side up and place a weight on top to flatten them. Before marbling, flip over the stack, so the X is on top.

In this project we used Dr. Ph. Martin's Spectralite and Golden Fluid Acrylics. Thin the Golden acrylics to the consistency of light cream. Use Spectralite as it is. The consistency of the paint is a major factor in marbling, which you will adjust as you go along. Mix and store your paints in baby food jars, film containers, or small plastic cups with tight lids. Mark the tops of the lids with a patch of the color.

Before marbling, stir the bath again with the whisk. Then, starting with just three or four colors, squeeze a few drops of paint onto the bath from an eyedropper and watch it spread. Pull a comb, hair pick or craft stick very lightly across the paint to create a pattern; then, pull the tool across the first pattern at right angles, or zigzag across it. Spatter paint on the bath with a toothbrush, if desired. To create dark outlines around light colors, put the dark color on

Before starting the marbling process, it is important to gather all your materials together. Then prepare the bath according to the directions given in the text. Whisk the bath several times to make sure the paste granules are thoroughly dissolved.

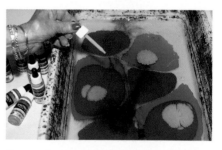

Use eyedroppers to drop color on the marbling bath or spatter color with a brush.

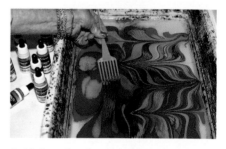

Swirl the colors into a lovely pattern using a comb or other pointed tool.

Place alum-coated paper on the bath, hold the corners diagonally and roll it onto the bath. Let it stand for a few minutes. (The alum-coating process is described in detail in the text.)

Pull the print directly upward from one end and hold it over the bath to drain. Lay it flat to dry.

Before making another print, clean the bath by pulling a strip of newspaper across the surface to pick up excess paint.

first, then drop the light one into it. The light color will spread and compress the dark colors into lines.

Some colors are more active than others and will spread beautifully. If the paint sinks to the bottom instead of spreading, give the bath a good whisking and try again. You can also stir one teaspoon of white gesso into the bath, or you can add a drop of pure ox gall or one or two drops of rubbing alcohol to the paint.

Pick up a piece of alum-prepared paper (treated side down and X side up) and hold it at diagonally opposite corners, slightly curving the center. Place one corner gently on the bath and hold it there as you carefully roll the paper onto the bath toward the other

corner, to avoid air bubbles. Don't stop in the middle. Wait ten seconds, pull the paper up carefully from one end, drain it over the bath and let it rest for ten minutes face up on a cookie sheet covered with newspaper. Over a sink or bucket, gently squeeze a water-filled sponge over the paper to rinse off excess paint and size, until the water runs clear. Lay the marbled papers on newspaper to dry. If the initial image is weak, re-marble the paper after it dries. If the papers curl when they are dry, iron gently on the back with a cool iron.

Before marbling the next piece of treated paper, clean the surface of the bath by holding four-inch wide strips of newspaper, cut slightly larger than the width of

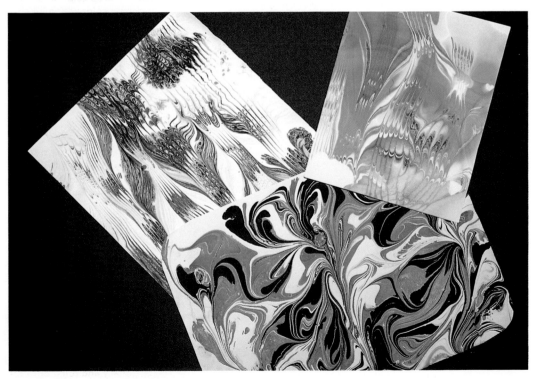

Make marbled papers in myriad patterns and colors and use them as focal points or beautiful accents. The organic nature of the marbling provides rhythmic elements for collage.

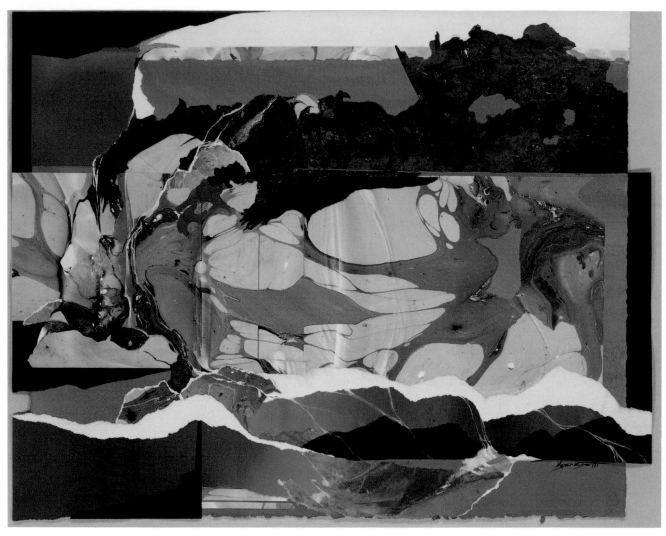

the pan, in both hands and dragging them across the surface to pick up excess paint. Discard the soiled paper and repeat the process until the bath surface is clean. This is absolutely essential to the success of your marbling. Many other factors contribute to the success or failure of marbling: atmospheric conditions, air currents and dust, for example. Try to keep conditions constant, if things are going well.

Marbled papers lend themselves beautifully to collage. You can use the free-form organic pattern in its entirety, making this the focal point in your design, or cut along the flow lines, arranging the pieces on your collage to create beautiful rhythms and repetitions of color. You can also connect marbled collage pieces with watercolor or acrylic washes to coordinate with the colors in the marbling and combine your marbled papers with your brayer and crystalline papers, putting them all together in larger works.

EARTH FRAGMENTS by Karen Becker Benedetti. Water media and marbled paper with gold leaf, 35″ × 42″.

This striking piece is what marbled collage is all about. The traditional stone pattern of marbling has been cut and combined with acrylics and watercolor in a powerful monochromatic design.

PROJECT FORTY-THREE: Embossing Paper for Collage

You can emboss almost any slightly raised shape on paper. First, use a stencil knife to carve design shapes for the embossing plate out of a single thickness of mat board. Protect the surface underneath the mat board you're cutting with another layer of mat board. Adhere these shapes with matte medium to a piece of coated mat board, which will be your embossing plate. Trim the edges of the design shapes with the stencil knife to a slight bevel so they won't break through the dampened paper when you do the embossing.

You can also adhere other objects to the plate such as string, punch cards, gravel, toothpicks, broomstraws, bamboo, thin buttons, latchhook canvas, berry basket pieces, textured wallpaper or corrugated paper, using items that are no thicker than the mat board shapes. Set thin objects on a layer of modeling paste to raise them up to the thickness of the mat board shapes. The surface depth of the plate should be fairly consistent. Fill in any deep areas between objects with modeling paste. Let the plate dry, then coat it with three layers of matte medium.

Use Arches cover printing paper, buff or white, or 90 lb. watercolor paper (100 percent rag or acid-free) with four deckled edges. Soak the paper in water for one-half hour or longer and drain.

For the embossing you should work in an area with strong side light, so you can see the shadows of the embossing. Place the damp paper over the plate and cover it with plastic wrap for protection from the embossing tools. The tools must have smooth surfaces; use fingers, spoons or small, soft

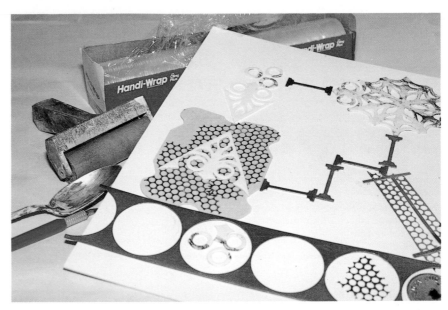

Once you have cut out your design shapes according to the directions given in the text, adhere them to a piece of mat board to make your embossing plate. All objects should be raised about the same distance from the plate. You can also adhere found objects.

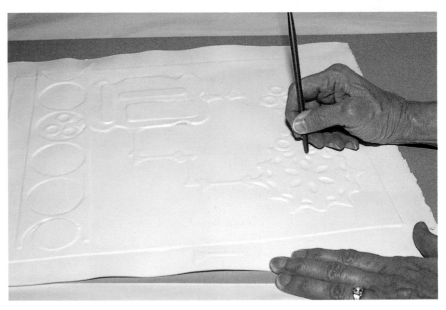

Place damp paper on the plate and cover with plastic wrap. Emboss by rubbing the edges of the objects on the plate with the handle of a brush, your fingers, or some other smooth surface. Leave the paper on the plate until it is partially dry.

brayers. Gently, but firmly, rub your tool on the paper along the edges of the plate until the design shape is evident on the softened paper. When you have embossed the complete design, leave the paper on the plate until it is partially dry, then remove it, and place it between two sheets of clean paper. Anchor the paper at the corners and let it dry completely. Don't place any weight on the design or you will flatten the embossing. If any holes need repair, patch them on the back with matte medium and bits of matching paper when the paper is dry.

To add color to an embossed piece, work in side lighting on dry paper, using a small brush and very little water with the paint. Don't brush color all the way to the edges of the shape; the color will spread on the paper because the sizing has broken down, so control is essential. Embossing casts subtle shadow patterns on paper, and you can use this effect to add interest to your collages. Make small embossed papers, repeating a shape or theme, to add to collages; or emboss areas of a large sheet and use this as a background or focal point for a collage.

THE BLUES III by Thelma Frame. Oil marbling on paper with embossing, 20″ × 13¾″.

The artist embossed Arches cover paper, then mounted blue marbled squares around the embossing, a nice combination of techniques.

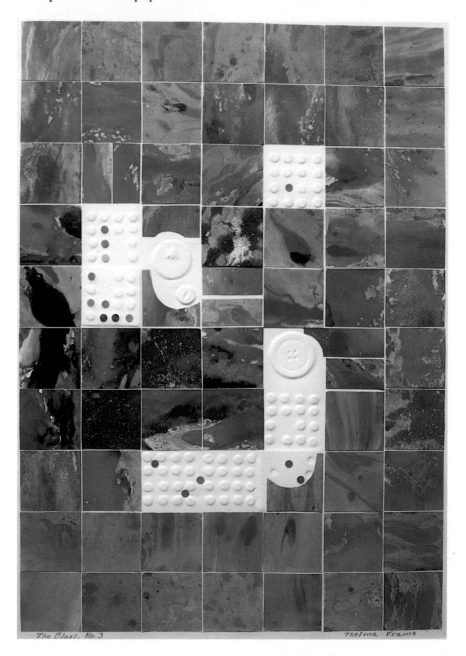

The Blues, No. 3 Thelma Frame

PROJECT FORTY-FOUR: Making Cast Paper for Collage

You can create three-dimensional paper collages easily from ready-made papers. First, select an object with a distinctive shape and contours. Clean the object well and coat it with gel medium, letting it dry thoroughly. For this project we used kinwashi heavy paper with fibers embedded in it, but you can try others, too.

Coat the paper on one side with a mixture of half modeling paste and half gel medium, and wait a short time until the paper is soft, but not fragile. Place the softened paper, coated side down, over the object and work it into the details of the object with your fingers. Coax the paper into the crevices and around the contours, carefully stretching and pressing the pliable, damp paper. Spray the paper occasionally with water to keep it pliable. If the paper tears, patch it with bits of paper softened with the medium mixture.

As the paper begins to dry, gently loosen it around the edges of the form. Continue to work the paper free as it dries. Remove it when it is firm, but still slightly damp. Set it aside to dry. Don't leave the paper on the form until it is totally dry, or it may adhere permanently.

Paint or collage your cast-paper piece and use it in a collage to add dimension or a dramatic focal point. Before you adhere the cast paper piece, examine the collage under directional lights for the most effective shadow patterns.

OCHRE, BLACK, RED by Roy Ray. Acrylic collage on board, 15" x 13". Private collection.

Ray uses a variety of materials, including handmade cast paper, found papers and layered, painted papers to give a dimensional effect to his collage pieces.

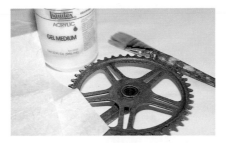

For this cast-paper exercise, we found a gear, scrubbed it, and wiped it with alcohol. Then it served as the form for our cast paper.

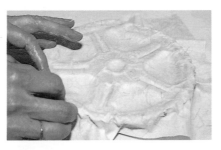

Kinwashi heavy rice paper was coated with a mixture of modeling paste and gel. When the paper was soft, we placed it on the form and gently pressed it into the teeth around the form.

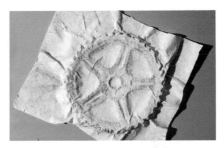

We lifted the finished piece from the form while it was still slightly damp, so it wouldn't permanently adhere to the gear. Now we have a nice three-dimensional piece to use in collage.

PROJECT FORTY-FIVE: Making Handmade Paper for Collage

There are two ways to make a simple mold (the screen onto which you pour your paper pulp) and deckle (the frame that shapes the edges of your paper). The first is to use an 8″×10″ set of canvas stretchers and a small picture frame that measures 8″×10″ at the outside edge. To make the mold, assemble the stretchers and staple fiber glass mesh door screen tightly across the flat side of the stretchers. The second option is to make two 8″×10″ frames out of flat picture molding and stretch

screen across one of them. To make a drying rack, place several thicknesses of newspaper on a wire cooling rack and lay a large sheet of blotter paper on top.

Gather discarded typing and copy papers, white tissue, dress patterns, scraps of watercolor and rice papers, and other soft papers to make your paper pulp. Toss in a small piece of colored paper to add flecks to the pulp. Old newspapers (excluding glossy, colored ads) and paper bags will yield soft, neutral-colored papers. Tear

some of the scrap papers into stamp-sized bits and place these in a rectangular plastic dishpan slightly larger than the mold. Cover the paper bits with water and soak them overnight.

Place the presoaked paper in small quantities (about ½ cup) with two cups of water in a blender. Check local garage sales for old blenders rather than using your kitchen blender. Grind the mixture for 10 to 15 seconds to the consistency of heavy cream. Don't overwork the blender: If the motor

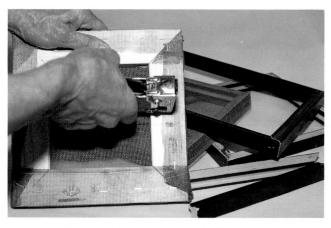

To create a simple mold and deckle, staple fiber glass screen to a small frame for the mold and assemble a same-size frame for the deckle.

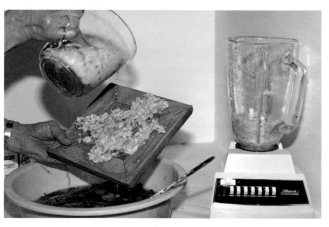

Soak small bits of soft paper and chop in a blender with plenty of water. Pour the pulp onto the screen in a random free-form shape, drain and flip onto layers of newspaper to dry.

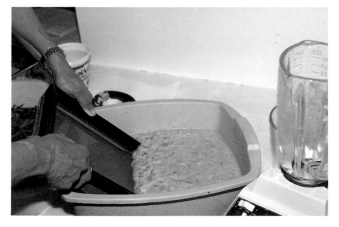

To make small paper sheets, hold the deckle tightly on top of the mold and scoop up pulp from a plastic dishpan. Shake gently side to side to mesh paper fibers and drain the water.

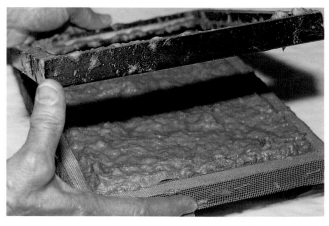

Lift the deckle off the mold and flip the sheet over onto newspaper to dry.

is straining, grind smaller quantities of pulp or add more water. The pulp should have a silky feel to it. Pour the liquefied pulp into a one-quart measuring cup. When you have finished making your papers, drain excess water from unused pulp and place the pulp in a trash container. Do not pour it down the sink drain.

To make a free-form shape, place your mold in a plastic dishpan, screen side up. Stir the pulp in the measuring cup, then pour it onto the mold to create the shape. The deckle isn't necessary for this. Let it drain for a minute, then flip the screen over onto the blotter on the drying rack.

To make small sheets of paper, stir the pulp before pouring it into a dishpan larger than your mold, to a depth of three to four inches. Holding the deckle firmly on top of the screen-covered mold with flat sides together, dip one end of the mold into the pan, sliding it through the pulp to pick up an even layer of pulp on the screen. Lift the mold and shake it gently from side to side, allowing the water to drain off. Then, remove the deckle and flip the screen over onto a blotter on the drying rack. If the paper does not release, gently push on the back side of the screen with a damp sponge. If you let your papers dry naturally, they will have interesting textures and curly edges. For a smoother surface, iron the paper gently while it is slightly damp.

If you wish to make flatter sheets, make a stack consisting of alternating layers of handmade paper, blotting paper and newspaper; place this stack between two ½-inch plywood boards, and press firmly to remove excess water, then weight the stack down overnight. The next day, leaving the blotting paper attached, spread your handmade papers out on newspapers to dry, replacing damp newspapers frequently.

If you wish, you can embed materials, such as weeds, seeds, ribbon, glitter, feathers or dried flower petals in the wet pulp, or pour and spatter liquid paints onto the surface. You can also place flat objects on slightly damp sheets of handmade paper, covering the objects with blotter paper and applying heat and pressure with an iron to imprint their shapes; or you can make three-dimensional forms by pressing a still damp piece of handmade paper into a mold, creating your own handmade cast paper. Experiment with tinting handmade papers and using a variety of papers for your pulp.

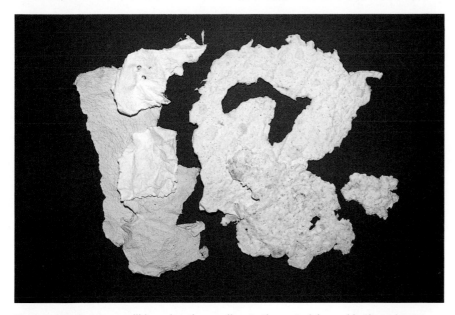

The handmade papers will be colored according to the materials used in the pulp.

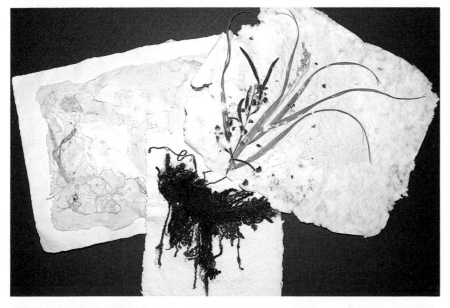

Fibers and natural materials may be embedded in the handmade papers before they dry. Handmade papers by Nita Leland.

DEMONSTRATION FIVE: Using Customized Papers in Collage

Our crystalline free-form made a colorful focal point for this collage. We were able to find lots of our own customized papers that picked up the striking colors in the free form. Except for a tiny strip of gold paper for contrast, the entire collage is created from papers we created ourselves using brayering, marbling, embossing and simple handmade paper techniques.

STEP ONE. In addition to the free-form created in Project 40, we had brayer and crystalline papers, handmade and marbled papers to work with. These materials lent themselves to organic abstraction and the pieces we selected were harmonious in color. We adhered the collage to stretched canvas.

STEP TWO. After adding gold mesh to the opening in the free-form, we adhered white paper to the back of it to keep the color bright. We placed the free-form on top of our crystalline paper and framed the paper with gold trim, backed by pieces of torn brayer paper. We trimmed marbled paper to make a strip along the bottom of the canvas and added gold paper to the edges.

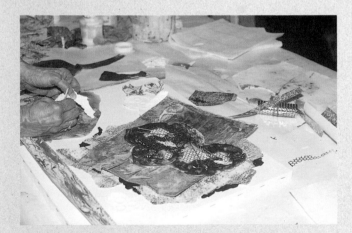

STEP THREE. We tore the brayer papers and arranged them around the focal point, which wasn't yet adhered. We marked their placement on the canvas, but the pieces were assembled and adhered to each other without attaching them to the canvas. We were still deciding what we wanted to do with the background.

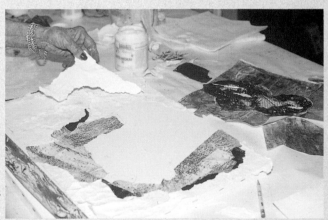

STEP FOUR. Handmade paper was the solution to our problem. We tore up bits of paper and layered it around the focal point, building up an attractive textured surface that wouldn't distract from the center of interest. After the handmade paper was adhered, we bonded the brayer paper frame and the marbled paper strip to the canvas.

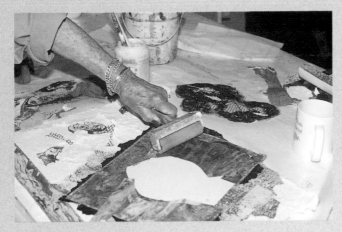

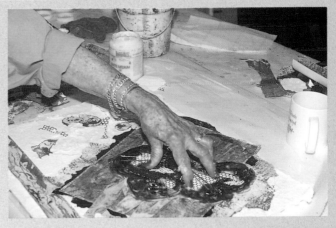

STEP FIVE. We had already cut out the area where the free-form would cover the crystalline paper and used some of the crystalline scraps for accents. Now we adhered the crystalline paper to the canvas, using a brayer to roll it down. We cut out bits of marbled paper that matched the bottom strip and adhered them to the canvas, along with pieces of gold mesh.

STEP SIX. We placed the crystalline free-form carefully to cover the cutout in the paper. We marked the placement lightly with pencil. We applied gel medium to the back of the free-form and then bonded it to the background. We placed weights on the piece until it was completely dry. Then we brushed a coating of matte medium over the piece, except for the free-form.

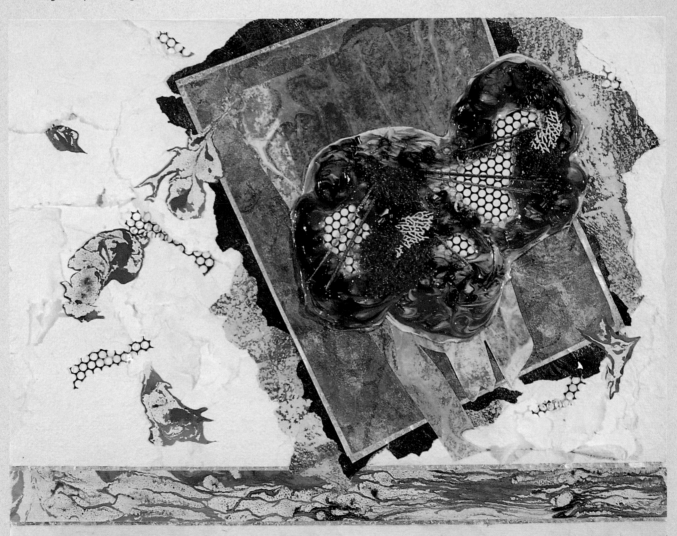

ALL THAT GLITTERS by Nita Leland and Virginia Lee Williams. Customized papers with acrylic paint and mediums on canvas, 16" × 20".

LOVER'S POINT by Gerald F. Brommer. Watercolor and rice paper collage, 22" × 30". Courtesy of Fireside Gallery, Carmel, California.

Explore this concluding section to discover everything else you've always wanted to know about collage!

CHAPTER FIFTEEN

So What Else Is New?

Because collage is a relatively new medium, experimentation is the rule. This leads to many questions about conservation procedures. During the early years of collage, and especially in the midtwentieth century, little attention was paid to the quality of materials and compatibility of media. As a result, museum conservators have watched helplessly as major acquisitions have flaked and floated to the floor.

Artists should always be concerned about permanence of their artwork. Consider lightfastness and reaction of pigments to pollutants to be matters of great importance. Ask museum conservators where you can learn about archival techniques and materials. See the Appendix for references on conservation practices. Two of these are the Digby book listed in the Bibliography and Wei T'o Associates listed under Resources.

No one can guarantee your collage art will last for centuries, but you can take precautions to keep it intact for a very long time.

- Use quality materials wherever possible: acid-free papers and supports, artists' quality paints and mediums.
- Coat supports with acrylic gloss medium or gel.

- Coat nonacid-free collage materials, such as cardboard or newspaper, on both sides with several coats of gloss medium.
- Avoid fragile materials that can't be coated, such as dried flowers or crumbling leaves.
- Finish your collage with a coat of gloss medium or gel and a top coat of matte varnish to reduce shine. Use Liquitex Soluvar or Golden varnish with UVLS for the best protection.

- Clean found objects thoroughly with alcohol and let dry before coating with medium. Acrylic paints and mediums will not adhere permanently to dirty or oilcoated surfaces.
- Dry each layer of your collage completely before adding succeeding layers, except for blotter paper layering.
- Shake or brush off loose materials (glitter, sand, wood chips) before framing.

ALL AMERICAN GAME by Bonny Lhotka. Mixed media collage, 34″ × 50″.

Lhotka transferred a monotype to Gatorfoam board and applied a piece of tinted, openweave fabric on top so the print showed through. Then she cut a circular shape through the fabric and board. Next she rotated the circle to reveal the round ball.

PROJECT FORTY-SIX: Creating an Environmental Collage

You can do your part by recycling trash into art, making an environmental collage or assemblage with bits and pieces of discarded objects: beads, bottle caps, broken pottery, clock parts, gears and wheels, jar lids, junk, marbles, metals, mirrors, nails and screws, nuts and bolts, bits and pieces of Plexiglas or mirror, and wire. This technique is called assemblage.

Utilize the shapes of the objects. Similarities establish unity, but look for a variety of sizes and subtle differences to create interest. Select materials for their patina, colors and textures. Design your environmental collage to take advantage of the contrasts and harmonies of the objects in their natural state. Clean your assorted objects thoroughly. Brush off loose dirt and rust flakes. Wash them, if necessary, or wipe them with alcohol to clean off oily residue. Coat well with gloss medium or gel.

Use stretched canvas or heavy watercolor board that has been coated on both sides with gloss medium or gel. Spread a thick mixture of modeling paste and matte gel medium (a bit more paste than gel) on your support. Imprint the wet medium in a few areas with your objects to repeat the shapes, then embed some of them, pressing them into the thick, wet medium. When adhering additional objects, you can apply the modeling paste/gel mixture to an area on the support and press the object into the wet medium; or you can apply the medium directly to the object, then press it firmly onto the support. With a small, damp brush, wipe off excess medium that oozes out around the edges of the objects, since modeling paste

LOST AND FOUND by Nita Leland and Virginia Lee Williams, 12″ × 14½″.
Here we added more found materials to the embossing plate we used in Project 44. The ring near the center was heavy, so we fastened it on with thin wire. Everything else adhered well with a mixture of modeling paste and gel medium.

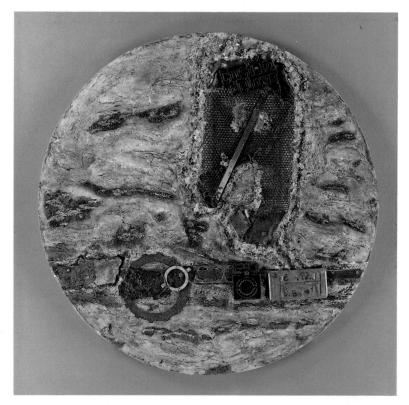

CUSTOM DELUXE by Virginia Lee Williams. Assemblage with found objects on canvas, 36″ diameter.
The stretched canvas circle was heavily layered with blotter paper and peeled paper. Found metal objects were embedded in a modeling paste/gel mixture and then the whole was painted with acrylics.

is opaque and cannot be removed after it dries. Let the support dry thoroughly.

Some objects may be a little too heavy for the gel/modeling paste mixture. To be on the safe side, wrap thin wire around the object in several places. Make a small hole in the support; push the wire through the hole and secure it on the back side. If necessary, you can conceal the wire with a touch-up of the gel/paste mixture.

If the objects relate to a theme, display them in their natural form. Otherwise, gesso the entire piece when the mediums are thoroughly dry. Layer with collage and paint with acrylics. Virtually no stone — or shell or paper — will be left unturned when the creative collagist is on the move. Surely, the world and all that's in it was created for us to put in our collages!

LUNA SHIELD by Frances Dezzany. Assemblage with found objects and handmade paper, 27″ × 13″ × 3″.

A fine assemblage of manmade and handmade objects, this piece is beautifully designed with limited color and striking value contrasts.

PROJECT FORTY-SEVEN: Other Possibilities With Collage

Throughout the book we've emphasized paper collage, but there are many other possibilities, including the assemblage project just described. Collage artists are limited only by their imaginations. In your home, on the street, at the beach—everywhere are materials that might be utilized in collage art. Here are a few ideas to whet your appetite for experimentation. Most materials can be adhered with any of the acrylic mediums, but you should use the modeling paste/gel mixture described in the environmental collage project to assure the adhesion of heavy objects.

- Make an all-fiber collage, using stitchery, weaving, knitting, quilting and soft sculpture. These materials have unlimited possibilities for displaying color and texture. Make the collage three-dimensional by padding the layers.

- Make a sculptured collage with plastic sculpture materials, such as Sculpey or Fimo. Follow directions on the package to shape the sculpture, then paint it with acrylics. Use the piece to create a focal point in your collage. Make several small ones to emphasize a theme and establish dominance.

- Make a three-dimensional collage inside a deep frame using textured, embossed or cast papers with small objects. Adhere the objects with a mixture of modeling paste and matte gel medium to a support that fits inside the frame.

- Create collage "books" like a shadow box, adhering layers in a box (such as a cigar box), to create an illusion of three-

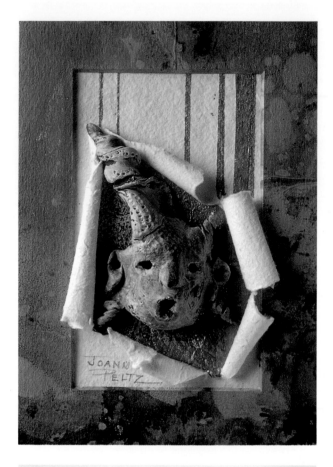

TRICKSTER by Joanne Peltz. Mixed media collage with clay sculpture, 5″ × 7″.

A painted clay figure is the focal point in this simple, but clever collage piece. Handmade paper curls back over the marbled mat to reveal the small sculpture.

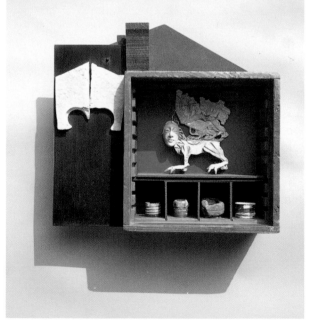

RELIC BOX II by Patricia B. Cox. Assemblage with found materials and Sculpey clay, 11″ × 12″ × 4″.

Fill small boxes with collage elements or found objects, and paint with acrylics. Shadow boxes make beautiful assemblages.

dimensional space, then gluing the box between the covers of an old book.

These are just a few ideas that might be a point of departure for your collage work. Whatever direction you may take, keep in mind several important points.

1. Use quality mediums and suitably prepared supports.
2. Base your collage on design principles.
3. Invent and innovate. Collage truly lends itself to this.
4. And most important—have fun.

PRESENTATION

Make your signature relatively easy to find—let your viewers know you're proud of your work. Most collages can be signed with a brush and acrylic paint, or if you prefer, you can use a pen or marker that is lightfast and waterproof. Textured pieces can be hard to sign, so tint a piece of watercolor paper to match the piece, sign it and adhere it to the collage. Then, coat the watercolor paper with matte medium.

Appropriate framing is another important consideration in collage. Your framing should provide protection for the artwork, if needed. Collages that have been coated heavily with medium and paint to protect materials from exposure to air may be framed without glass or acrylic glazing, particularly if they are adhered to canvas.

When in doubt, protect the artwork with glazing. An experienced framer should be able to advise you. Use glass or acrylic glazing if the collage is adhered to paper or

(Left)
YESTERDAY by Rose Mary Stearns. Three-dimensional collage with paper, cloth, photo and cardboard, 10″ × 8″ × 3″.

In a collage take-off of a shadow box, Stearns made a box to look like a book in every detail, with a small mat opening that reveals torn pages with progressively smaller print receding into the distance and a collage landscape at the back.

(Below)
WINTER GROUNDSCAPE by Roy Ray. Acrylic and cast paper collage on board, 23″ × 19″. Private collection.

Collages on low-relief textured supports can be simply framed without glass because all materials are encased in acrylic mediums.

RIVERS OF MY MIND by Peggy Brown. Transparent watercolor collage with graphite drawing, 39″ × 29″.

Brown's collage should be protected by Plexiglas or glass with unobtrusive framing, so the presentation will not detract from its quiet beauty. On the other hand, *Custom Deluxe* on page 122 can be left unglazed and unframed.

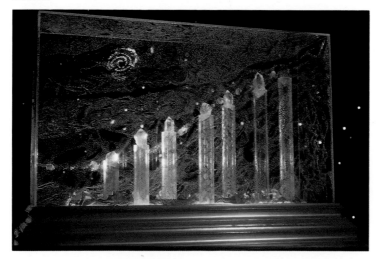

THE CHI OF HARMONIC CONVERGENCE by Mary Carroll Nelson. Tube and sheet acrylic with ink, polyform clay, crystals and wood, 16″ × 20″ × 4½″.

This mystical creation is housed in an acrylic box on a wood base. The assemblage/sculpture may be viewed from all sides, as might any sculptural collage form.

board, or if weight is a factor or shipping is necessary.

Avoid non-glare glazing, which tends to deaden color. So-called "invisible" glass is highly effective, but expensive. Consider UV protective glass for additional protection from ultraviolet rays. In addition:

- Select a frame suitable to the collage. Sometimes simple is better.
- Use a frame deep enough to prevent the collage from touching the glazing, or insert foam board or mat board spacers.
- If possible, seal the back of a wood frame with brown paper to protect the piece from insect damage.
- Frame dimensional collages in acrylic box frames.
- Frame memorabilia in acrylic box frames to preserve them from deterioration.

Coordinate framing with artwork to achieve a distinctive look. A mat is not always necessary. If you mat your collages, use acid-free matting. Create custom mats and frames (use a one-inch or wider plain wood frame, with no carving) by collaging them with materials that complement the artwork. Apply lightweight papers, like brayer papers, crystalline, or marbled papers, sheet music, even coated newspapers. Cut or tear the paper into pieces and adhere it to the frame with medium. When the frame is dry, coat it with matte satin varnish.

Here are some more ideas for matting:

- Cover a mat with collage materials, such as grasscloth, foil paper, marbled or brayer papers. Brush matte medium or matte gel on the back of the paper, wrap it around the mat opening, and adhere it to the

back of the mat.

- Create a mat effect directly on the collage by adhering strips of matching collage papers around the edges of the collage.
- Float the collage on top of the mat board. Cut a solid sheet of mat board or illustration board several inches larger than the collage, adhere papers around the edges to suggest a mat and adhere the collage on top.
- Marble directly on the mat board.
- Create a shadow-box effect; cut narrow strips of ¼-inch foam board and adhere them under the edges of the mat to create a space between the artwork and the mat or on top of the mat edge to create space between the mat and the glazing.

COPYRIGHT ISSUES

Plagiarism is the illegal use of copyrighted material. Artists who use small bits and pieces of magazine advertisements or illustrations, newspapers, published photographs, postcards, greeting cards, etc., probably needn't worry about this. However, the artist who enters collage competitions, makes reproductions of his or her collage artwork, or uses such collage in art that is sold to others, needs to give serious thought to this issue and perhaps should seek professional advice. The matter may revolve around how much of the picture is used, whether it is a focal point or used as part of a background, and whether or not the artist is enjoying financial gain at the expense of the creator of the original material. You must get permission when other artists' materials are a major part of your work.

PHOTOGRAPHING COLLAGES

If you don't have the necessary equipment or know-how to take

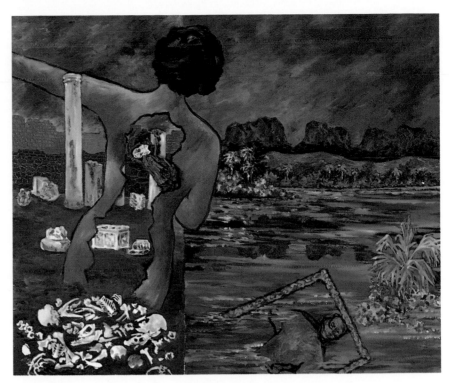

HOLDING ON by Chispa Bluntzer. Oil on canvas with found objects, 36″ × 42″ × 2½″.
Unlike the other artists in this book, Bluntzer works in oil on canvas. She uses found materials such as wood and bone to create ''images that are symbolic of aspects and experiences in [her] life.'' This highly original collage is very personal to the artist in terms of the materials and images she has combined. You needn't worry about infringing another artist's copyright if you are working this way.

good slides, seek professional advice or have the slides taken by a professional custom color lab. Good photographic equipment and film are costly. It may be more cost-effective for you to leave it to the experts.

Photograph artwork before matting and framing; reflections pose problems. Fill the viewfinder with the image. To avoid background distraction, use a black background or a temporary wide, black mat around the art. Use professional film and take it to a professional color lab for processing. If the color bias is off, a color lab can make some adjustments. Exposures can also be made lighter or darker. These services cost extra, but they are worth it to get quality slides. Tape the finished slide with silver photographic tape to mask out extraneous elements.

When you get consistent results with your photography, take eight to ten slides of each piece, because original slides are sharper and truer than duplicates. You'll need slides to submit to galleries and shows and to provide records. Also, if you give slide talks, you want the best possible representation of your art.

For details on how to photograph your artwork, see *Photographing Your Artwork* by Russell Hart.

GALLERIES AND COMPETITION

Sooner or later you may wish to sell your work, approach galleries for representation or exhibit in competition. Here are some guidelines.

To be considered for a gallery, you must present good slides and color photographs of your work. If

you do artwork other than collage, offer these separately to suitable galleries. Prepare a biography or resume and include a good, professional photograph of yourself, not a snapshot. If you are showing your originals, have quality framing on all pieces.

No matter how fantastic your collages are, you won't get anywhere in competition if you don't follow the rules. Read every word of the show prospectus carefully. Some shows do not allow collages; others set limitations on what kind of collage is acceptable. Above all, send good slides. In most cases, even if your work is accepted in the slide competition, it will not be hung unless it complies with the restrictions. Frequently, there are size limitations, as well.

Size and weight are major factors in shipping collages. You need shipping crates large enough to accommodate adequate packing and sturdy enough to protect the collage. Some exhibitions require wood crates. Keep packing material as simple as possible (bubblewrap works well), so it will be easy for shippers to return the artwork with the same protection. See what is available at packing and shipping facilities. Ask artists in your area where these services are available.

Don't take competition too seriously. Win or lose, the decision is one person's opinion. Today's reject may be tomorrow's Best-of-Show.

CHILDHOOD DREAMS by Jeny Reynolds. Mixed media collage on watercolor paper, 30" × 22".

It takes a good camera and lots of practice to get acceptable transparencies of collage works. The diverse materials must be in sharp focus, so the intricacies of the piece may be appreciated. What appears at first glance to be childish scribbles, on closer examination turns out to be delightful oil pastel sketches, surrounded by elements of cloth, beads, wood, rhinestones and Sculpey.

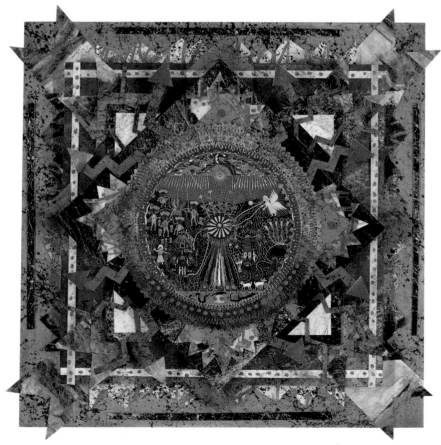

QUILT OF MIND by Ann L. Hartley. Mixed media collage, 12" × 12". Collection of Richard and Rochelle Newman.

Collage doesn't get any better than this. This intricate piece is beautifully designed and executed, and would certainly attract attention in competition.

Conclusion

Collage is like a hall of mirrors. Every direction you look, you see something different and visually stimulating. For collage artists, this is the fascination of collage and the origin of what we call the "collage attitude."

The collage attitude isn't a special talent; it's a state of mind. You may already have some of these characteristics; others develop naturally as you work and become part of your artistic style. Every attribute you have helps you to be a better artist. Look at the checklist on this page to see how you measure up.

Trust your instincts. Find your themes and symbols and use both the sublime and the ridiculous to give meaning to your art. Enjoy the process, have concern for quality, and the product will be worthwhile. Use design as a framework to bring order out of chaos.

The fine art of collage has infinite possibilities for you. Nothing is more satisfying than to work at something you love to do. One of the great things about collage is that it can be challenging and fun at the same time. No matter where you begin, you get better the more you do it. You can be a serious professional and still play and experiment with collage, always learning and growing as an artist.

Use restraint and good taste and you elevate your collage art. No one can predict what the art of the twenty-first century will be like, but we're placing our bets on collage. The potential for originality, experimentation, change, growth, personal expression, spirituality and environmental impact exists in collage to a greater extent than almost any other medium you can name.

And the best part of it is, you can do it. Experiment. Be creative. Have fun. You're a collage artist!

The Collage Attitude Checklist

- open mind
- sense of humor
- playful, fun-loving
- childlike
- hard-working
- environmentally aware
- socially aware
- artistically aware
- spiritually aware
- creative
- spontaneous
- intuitive
- original
- flexible, open to change
- non-judgmental
- patient
- adventuresome
- risk-taking, daring
- impulsive
- energetic

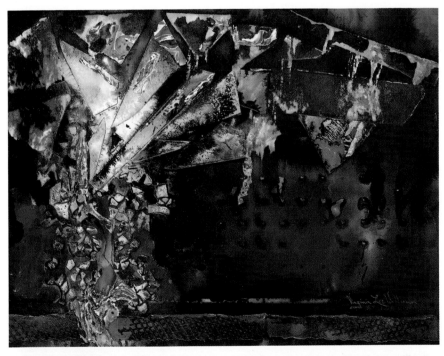

SILENT LUCIDITY by Virginia Lee Williams. Customized papers with acrylic paints on illustration board, 16″ × 20″.

Whether you sharpen your scissors and dive into a stack of magazines or make customized textured and marbled papers, the wonderful world of collage is waiting for you. Even the creator of this beautiful piece was a beginner once and you can do it, too.

Appendix

MATERIALS

Listed here are many materials we have used with good results. Don't hesitate to experiment with other products and items. Details about these materials are given throughout this book.

Mediums and Paints for Collage

acrylic mediums (Liquitex or Golden): gel medium, gloss medium, matte medium, matte gel medium, modeling paste, Absorbent Ground, Soluvar, Golden varnishes with UVLS

acrylic paints, tubes or liquid (including iridescent and metallic colors): Liquitex, Golden, Grumbacher, Dr. Ph. Martin's Spectralite

colored pencils and crayons (pastel, wax-based or watercolor)

gesso, white or colors: Liquitex, Daniel Smith, Golden

graphite pencils

inks or liquid watercolors (lightfast and waterproof): F.W. Steig, Rotring ArtistColor

Krylon matte spray

markers (lightfast)

oil pastels, pastels, charcoal

watercolors or gouache (artists' quality): Winsor & Newton, Holbein, Rowney, Grumbacher Finest

watercolor mediums: ox gall, Aquapasto

Supports

bristol board (3- to 5-ply)

canvas, stretched

canvas board

illustration board

mat board

watercolor board

Ready-made Papers for Collage/Printing

blotter paper (acid-free)

charcoal and pastel paper

Chromarama or Color-Aid papers

handmade papers, Indian Village paper

metallic papers

printmaking papers

rice papers (kinwashi heavy and light, kozo, taiten heavy and light, unryu and others)

stencils, stencil paper

textured papers, wallpaper

tissue paper, white: Niji Craft Pack

watercolor paper (90 lb., 140 lb., 300 lb.; pH neutral)

Tools

brayer (soft)

brushes: synthetic or sabeline in various sizes, bristle brushes, hog bristle brushes from hardware store. (Don't use your good watercolor brushes with acrylics.)

hair dryer(s)

paint roller (4-inch fuzzy with metal handle)

pencils, erasers

pliers

ruler or yardstick (heavy, metal)

scissors, tweezers

strainer (mesh)

rubber spatula, palette knife, old spoon

spray bottle (pump)

staple gun, staples

toothbrush or denture brush

utility knife, X-Acto knife

Miscellaneous Materials

alcohol

bucket (1 gallon plastic)

cornstarch

drop cloth

freezer paper (waxed on one side)

Gatorboard

gloves (plastic)

masking and cellophane tapes

notebook

old towels or cleanup cloths, heavy paper towels

plastic wrap or sheeting (different weights)

plastic bags

Plexiglas for palette (approx. 12″ × 18″)

plywood (3/8-inch thick, 18″ × 24″)

soap in a jar for final brush cleaning

sponges

tracing paper

Vaseline

Here are some suggestions for additional collage materials you might find around the house. The more materials you have to play with, the more fun you'll have with collage. See what else you can find!

FOUND MATERIALS

art reproductions, posters, prints, engravings

bags (mesh, paper, foil)

beads, marbles

berry boxes

bills, receipts, labels, price tags, punch cards

bottle caps, lids

broom straws, drinking straws

bubblewrap, packing material

burlap, gauze, cheesecloth

buttons, keys, pins, combs

catalogs, comics, playing cards

coins, stamps

colored Mylar, metallic paper

corrugated paper, sandpaper

craft shop items, glitter

diaries, journals, programs, tickets, maps

doilies—paper, fabric, plastic

dress patterns, sheet music

fabrics, fibers, lace, ribbon, yarn

feathers, flowers (dried), leaves, shells, stones, twigs

"found" paper, objects, junk

letters, greeting cards, postcards, envelopes

magazines (good quality) such as *National Geographic*, *Architectural Digest*, *Vogue*

metal, wire scraps

mirror, Plexiglas (broken)

natural materials (beans, seeds, pods, herbs, weeds)

needlework canvas

nuts, bolts, nails, screws, gears, wheels, clock parts

objects with raised design

photographs, memorabilia

pottery, broken

press-on type

sand and gravel, from craft store or gravel pit

stencils, stencil paper

string, rope

typing paper, copy paper

unfinished paintings, drawings

wallpaper (embossed, textured, grass cloth), waxed paper

wood chips, scraps, shavings, sawdust

wrapping papers

WHATEVER!

MARBLING SUPPLIES

alum from grocery store

acrylic paints: Dr. Ph. Martin's Spectralite or Golden Fluid Acrylics

bucket (at least 4-gallon)

craft sticks

distilled water (2 gallons)

hand cream (non-greasy, e.g., Dermagard)

jars (small, with lids)

newspapers

papers (See page 110.)

paper towels (heavy)

plastic combs, hair lift

plastic container ($12'' \times 18''$ or larger with low sides, or litter pan)

plastic gloves

sponges

tablespoon

wallpaper paste, cellulose (Metalyn)

wire whisk

HANDMADE PAPER SUPPLIES

scrap papers: typing paper, copy paper, white wrapping tissue, dress patterns, watercolor papers, rice papers, soft white papers, small bits of colored paper, newspaper (not glossy advertisements), paper bags

canvas stretchers (1 set, $8'' \times 10''$)

$8'' \times 10''$ wood frame

fiber glass mesh door screen ($10'' \times 12''$)

blender (preferably not your good one)

large measuring cup (4-cup)

plastic pan ($12'' \times 16''$)

blotting paper sheets

newsprint, clean newspaper

2 plywood boards (at least $9'' \times 12''$)

sponges

objects for embedding in pulp (See Found Materials list.)

RESOURCES AND PUBLICATIONS

Check for quality collage materials with your local art materials dealers first. Some craft and school supply stores will have useful items, also. Some items are available through the mail order suppliers listed below; write or call for catalogs. For found objects, explore flea markets, antique shops, hardware stores, lumberyards, building sites, junkyards, fabric shops, garage sales, and at your feet along the streets.

Art Materials

Aiko's (Oriental papers)
3347 North Clark Street
Chicago, IL 60657
(312) 943-0745

Andrews, Nelson, Whitehead
31-10 48th Avenue
Long Island City, NY 11101
(718) 937-7100

Dick Blick
P.O. Box 1267
Galesburg, IL 61401
(800) 447-8192

Golden Artist Color, Inc.
New Berlin, NY 13411
(800) 959-6543

Jerry's Artarama
P.O. Box 1105
New Hyde Park, NY 11040
(800) U-ARTIST

Daniel Smith
4130 First Avenue South
Seattle, WA 98134-2302
(800) 426-6740

United Art and Education Supply Company
P.O. Box 9219
Fort Wayne, IN 46899
(800) 322-3247

Yasutomo and Company
490 Eccles Avenue
South San Francisco, CA 94080
(415) 737-8888

Marbling

Colophon Book Arts Supply
3046 Hogum Bay Road N.E.
Olympia, WA 98506
(206) 459-2940

Miscellaneous Resources

Florida Shell Factory
5129 53rd Avenue
E. Bradenton, FL 34023
(813) 758-7741

Wei T'o Associates, Inc. (archival materials)
P.O. Drawer 40
Matteson, IL 60443
(312) 747-6660

Collage Societies

Collage Artists of America
14569 Benefit Street #106
Sherman Oaks, CA 91403

North Coast Collage Society
14631 40th N.E.
Seattle, WA 98155

Society of Experimental Artists
P. O. Box 10929
Bradenton, FL 34282

SLMM
society of layerists in multi-media
1408 Georgia N.E.
Albuquerque, NM 87110

Selected Bibliography

Ades, Dawn. *Photomontage*. New York: Thames and Hudson, 1986.

Brigadier, Anne. *Collage: A Guide for Artists*. New York: Watson Guptill, 1970.

Brommer, Gerald. *The Art of Collage*. Worcester, Massachusetts: Davis Publications, 1978.

———. *Watercolor & Collage Workshop*. New York: Watson Guptill, 1986.

Brow, Francis. *Collage*. New York: Pitman Publishing, 1963.

Chambers, Anne. *The Practical Guide to Marbling Paper*. New York: Thames and Hudson, 1986.

———. *A Guide to Making Decorated Papers*. New York: Thames and Hudson, 1989.

Davis, Sally Prince. *The Fine Artist's Guide to Showing and Selling Your Work*. Cincinnati: North Light, 1989.

Digby, John, and Joan Digby. *The Collage Handbook*. London: Thames & Hudson, 1987.

Hart, Russell. *Photographing Your Artwork*. Cincinnati: North Light Books, 1992.

Heller, Jules. *Papermaking*. New York: Watson Guptill, 1978.

Hoffman, Katherine. *Collage: Critical Views*. Ann Arbor, Michigan: UMI Research Press, 1989.

Janis, Harriet, and Rudy Blesh. *Collage Personalities, Concepts and Techniques*. Philadelphia: Chilton Book Company, 1967.

Leland, Nita. *The Creative Artist*. Cincinnati: North Light Books, 1990.

———. *Exploring Color*. Cincinnati: North Light Books, 1985.

Masterfield, Maxine. *In Harmony With Nature*. New York: Watson Guptill, 1990.

Maurer, Diane Vogel, with Paul Maurer. *Marbling*. New York: Crescent Books, 1991.

Rodari, Florian. *Collage: Pasted, Cut, and Torn Papers*. New York: Rizzoli, 1988.

Roukes, Nicholas. *Acrylics Bold and New*. New York: Watson Guptill, 1986.

Shannon, Faith. *Paper Pleasures*. New York: Weidenfeld & Nicolson, 1987.

Wescher, Herta. *Collage*. New York: Harry N. Abrams, 1968.

Wolfram, Eddie. *History of Collage*. New York: Macmillan Publishing Company, 1975.

Index